A COVENANT OF SEASONS

HUDSON HILLS PRESS NEW YORK

A COVENANT OF SEASONS

MONOTYPES BY JOELLYN DUESBERRY

POEMS BY PATTIANN ROGERS

with an essay by David Park Curry
and contributions by
Robert Adams, Roger Mandle, and John Walsh

FIRST EDITION

© 1998 by Hudson Hills Press

Monotypes © 1998 by Joellyn Duesberry

Poems © 1998 by Pattiann Rogers (see page 155 for publication history)

"Portals to Gardens of the Mind" © 1998 by David Park Curry.

All rights reserved under International and Pan-American Copyright Conventions.

Published in the United States by Hudson Hills Press, Inc., 122 East 25th Street, Floor 5, New York, NY 10010-2936.

Distributed in the United States, its territories and possessions, and Canada by National Book Network.

Distributed in the United Kingdom, Eire, and Europe by Art Books International Ltd.

Editor and publisher: Paul Anbinder

Copy editor: Virginia Wageman

Proofreader: Lydia Edwards

Designer: Betty Binns

Composition: Angela Taormina

Manufactured in Japan by Dai Nippon Printing Company.

LIBRARY OF CONGRESS CATALOGUING-IN-PUBLICATION DATA

Duesberry, Joellyn, 1944–
 Seasons : a covenant of seasons / monotypes by Joellyn Duesberry ; poetry by Pattiann Rogers ; with an essay by David Park Curry and contributions by Roger Mandle and John Walsh.
 p. cm.
 Includes bibliographical references.
 ISBN: 1-55595-156-2 (pbk. : alk. paper)
 1. Seasons in art. 2. Arts, American. 3. Arts, Modern—20th century—United States. I. Rogers, Pattiann, 1940– II. Curry, David Park. III. Title.
NX650.S43D84 1998
769.92—dc21 98-20354
 CIP

CONTENTS

Items set in *italic* type are monotypes by Joellyn Duesberry. Items set within quotation marks are poems by Pattiann Rogers.

AUTUMN

WINTER

FOREWORDS

Joellyn Duesberry and Pattiann Rogers convince us of nature's sufficiency, that we are not impoverished or abandoned. It is such an important theme that it rules out fashionable distractions: irony is of no more interest to these artists than it was to the psalmists, and though each is a fine technician, style cannot be for them an end any more than it was for a celebrant like Charles Burchfield.

The achievement in this book is nothing less than to bring us back to life from our inattention. This is art the way it should be—conducive of wonder, open to hope.

ROBERT ADAMS

It was an inspired idea to pair Joellyn Duesberry's serene, summarizing landscapes with Pattiann Rogers's passionate word pictures. Duesberry keeps her distance as she looks at a spring meadow, jotting down a flowering tree and shrubs and fields with swaths of color and big angular patches. Rogers wades right in: " . . . this spring tumult / of magenta sorrel, here in this noisy / bee-scavenged field of wild, unruly / daisy, dewberry and rue, here is where / all despairs and frantic beseechings / wheel and ravage." Both are looking for understanding. Duesberry finds it by grasping the structure and the main elements of the changeable nature she sees. Rogers finds it by fastening on the particulars of nature and wringing out of them unexpected human truths. This book invites us to think not only about nature as treated by these two keen-eyed interpreters, but about the rival powers of words and pictures.

JOHN WALSH

AN APPRECIATION

Remarks like mine should rightly follow, not introduce, the reader's experience with a book like this. As an overzealous docent in a gallery might answer all the questions a viewer could possibly have about a work of art before he or she has had the chance to experience it, written introductions might snuff out all the viewer's immediate joy of encountering this book. So I will be brief as I express admiration for this remarkable collaborative achievement of Joellyn Duesberry and Pattiann Rogers.

This book *is* a joy: it overwhelms the reader with rich colors and diverse places where it is possible to leave one's heart. Rogers's poems conjure strong mental pictures, while Duesberry's monotypes make us struggle for inner words to describe her rich combination of medium and image. This collaboration between two highly creative souls whose inspirations come from nature follows a long tradition of the *livre d'artiste*. From seventeenth-century Dutch emblem books, in which artists illustrated in visual symbols the compact moral message of the accompanying poems, to Jasper Johns's prints published with Samuel Beckett's text in *Foirades/Fizzles* (London: Petersburg Press, 1976), writers and artists have put together words and images to strike sparks from their joint effort. In certain instances the poet's words clearly illuminate the printed image, while in others the illustration amplifies the text. In *Covenant of Seasons* there is a coincidental relationship between the written and printed images, connecting Duesberry's and Rogers's common sources and their different pathways to expression. None of the works of art in the book were created in relation to one another, yet there is a remarkable sympathy among them.

As complementary as Duesberry's graphic images may be to Rogers's poetry, they stand on their own as a singularly adventuresome suite. Her monotypes are strong in form and color, yet they are fragile in that each is a singular, risky attempt to manipulate pigments that defy Duesberry as she paints on a plate that will be printed in reverse. She has conquered nature through her choice of subjects and details, yet the natural pigment materials she uses are at the very edge of her control. Working in monotype, she has only one chance to make it all come together. She works quickly to

keep the images and pigments fresh, yet guiding her instantaneous gestures are years of studying art history, drawing, and painting.

The freshness of Duesberry's landscapes inspires the viewer to ask substantial questions about the complexity of both art and nature. Reproduced in this book, however, Duesberry's monotypes create a paradoxical experience for both the artist and the viewer. The prints here represent a singular act and experience that have been duplicated in a mass-produced form.

Pattiann Rogers's poems describe for the reader, through elegant images of actuality, simple experiences on which she builds larger topics for thought. Her words read and sound so good together that they seduce the reader to confront significant issues by describing the commonplace that he or she might otherwise overlook. From these descriptions, Rogers assembles a universe that challenges and amazes us. More than compassion, Rogers's poems show an urgency about time through her awareness of the meaning of the seasons and of the fragility of life itself. In this regard, she mirrors Duesberry's depictions of the particularity of life and the passage of time, which are amplified through the tension between her choice of image and medium. There is exuberance and foreboding in the imagery of both their work.

This is a highly moral book: the lessons demonstrated by this collaboration are several. First, we must never forget that we all are part of nature; we have responsibility for it, and thus responsibility for ourselves. Next, we must recognize, given the fragility and temporal nature of life, that our choices are finite. These choices resonate with our own nature (our past history—our souls) and direct our gaze. This gaze must be focused as it is challenged by the signals—if we can read them—that impact from the natural world. The reader will learn to see nature in rich new ways through the eyes, pen, and brush of Rogers and Duesberry. Thus, the works of art that comprise this book are acts of courage, in the end giving strength and purpose to others through their directness and power.

ROGER MANDLE

A COVENANT OF SEASONS

GOD'S ONLY BEGOTTEN DAUGHTER

If furling scarves of fire, flying
orange ribbons of bonfire by a dark lakeside
are beautiful, then she is beautiful.
If blue shrouds of snow or the fragrances
of summer grass freshly cut at dusk are desired,
then she is passion.

If the spawning of salmon fighting
upstream is a drama of obsession,
she is tragedian; if the grouse
in their mating are antic and raucous,
she is jester, clown. If the dart out
and back of an eel in its coral
cave is circumspect,
then she is so.

A vessel, yes, she contains like a sea,
like a scroll, like a crystal its pattern,
secure, symmetrical as honeycomb, woven
like a rainforest canopy, as rotund
as a pottery pitcher, as seamless
as a blown-glass jug, as porous
as cinnamon fern in a dawn drizzle.

If rows and rows of thin black
seeds lying in their canoe-shaped
pods atop multitudes of yuccas
scattered over the autumn plains
are countless, then every number
belongs to her.

And if bee plants and vase flowers,
ricebirds, whiptails, green
lacewings, frozen chorus toads, come
again and again, then she has always known
how to remain, promised, anointed,
her body, her face, the only one
in all our heavens, sole heiress
in whom we are very well pleased.

SPRING

Granite Quarry Triptych, 1996, 67 × 60 inches. Courtesy James Graham & Sons Gallery, New York

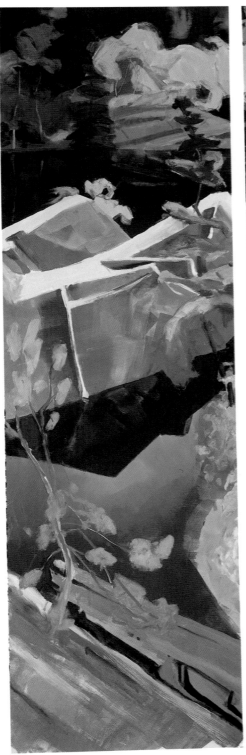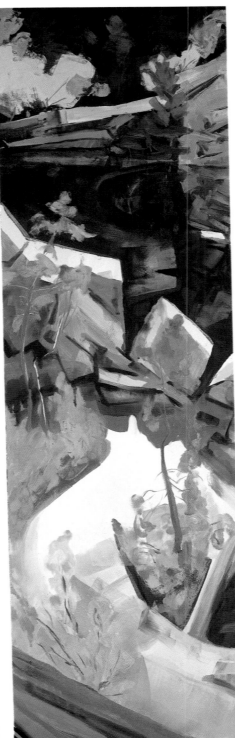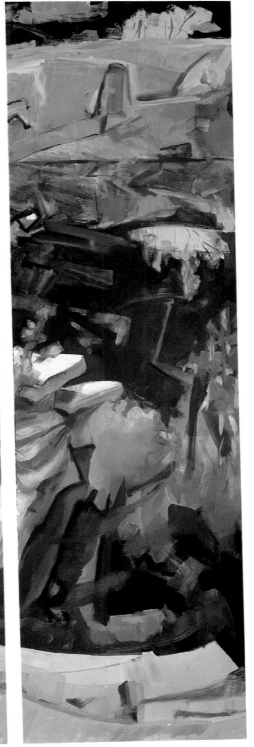

Lupine Field I, 1994, 6½ × 14¼ inches. Courtesy James Graham & Sons Gallery, New York

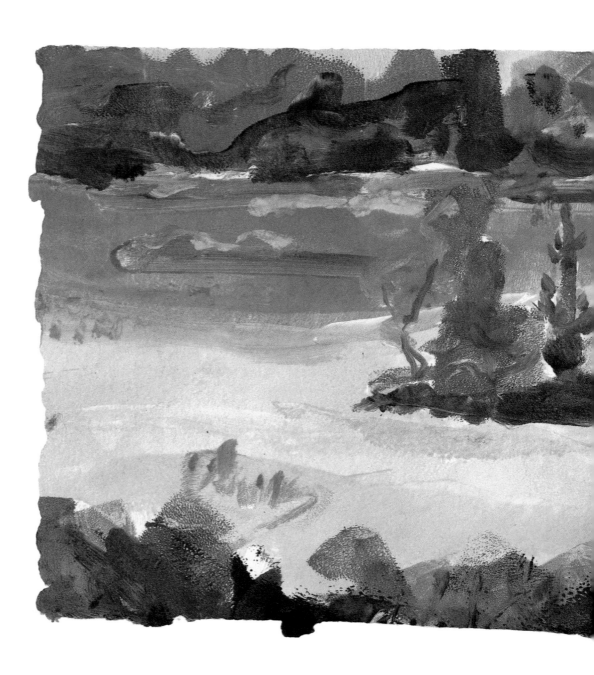

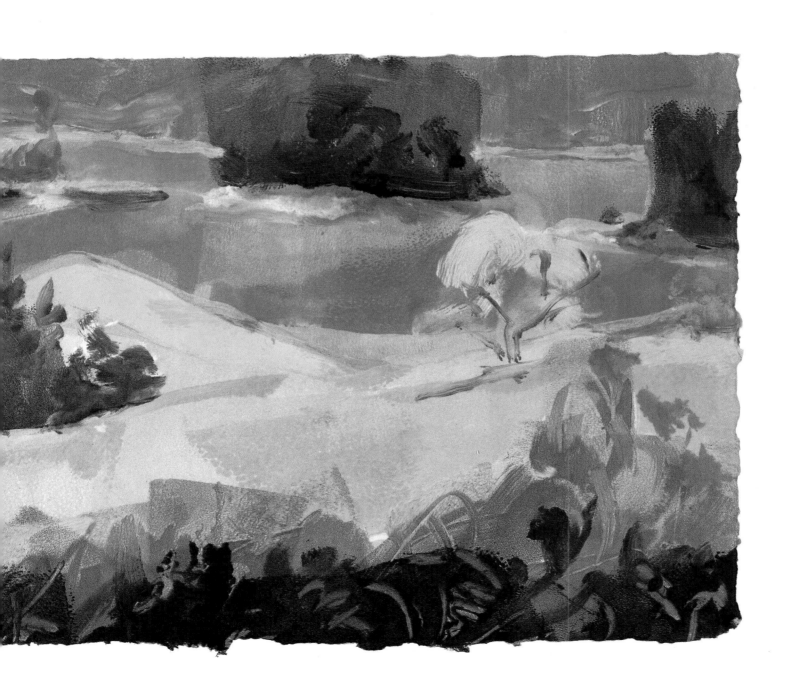

Padre Jim's Bridge II, 1993, 27 × 20 inches. Courtesy Robischon Gallery, Denver

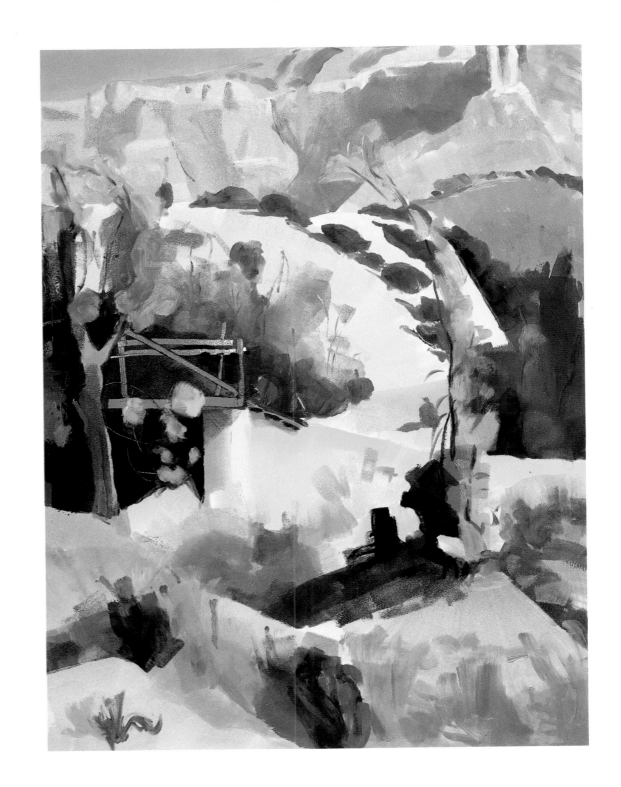

CONSIDER THE LILY

The obvious way first—blackberry, blue bead,
Easter and yellow pond, spider, swamp,
trout, rosetwisted, Indian cucumber,
colicroot.

Yet consider the lily a voice, its speech
carried blue-tipped, plaited and parallel
veined, rosette and basal murmur, alluring,
a seduction along peaty bog edges, moist
wooded slopes, meadows, through thickets,
over low sandy sites.

And look at lily—one "l" reaching
that way to the east, one "l" stretching
this way to the west—an embrace
it can never abandon.

Remember the lily moon, a full
flower every month; and the frothing
lily, there, never there, at the creek's
spill; and sugar lily/lily ice, spooned
and blooming in a silver bowl.

Consider *lily* on the tongue, a lullaby.
Lily . . . lily . . . it takes the sun, clucks
the light, makes a folded leaf
of fire.

Imagine the lily itself a tongue,
having become the white word it utters. *Lily,*
in fact, made flesh.

Picture the tongue a lily
saying *lily*. Such a smooth,
fragrant petal-licking it makes. One wants
to kiss it, bite it, suck it
to silence.

Say lily to me now then, luscious
flower. Don't you want to? Consider
a pure lily seduction—sarsaparilla,
featherbell, flesh and devil's bit,
zephyr, sessile. It could be perfect,
your basal tongue-lulling, lily-licking,
the moist thickets, the fold,
the froth, the rooted blooming
finally encompassed and in that moment
fully believed to be fully found.
Say *lily* to me now.

Burnt Meadow, South Platte River V, 1991, 25¼ × 37½ inches. Courtesy Robischon Gallery, Denver

April on the River III, 1993, 27 × 20 inches. Courtesy Robischon Gallery, Denver

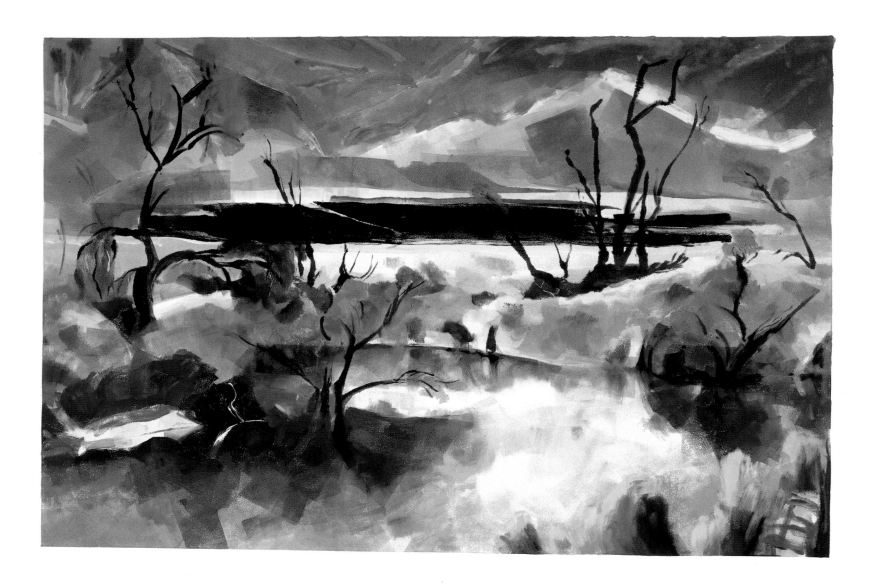

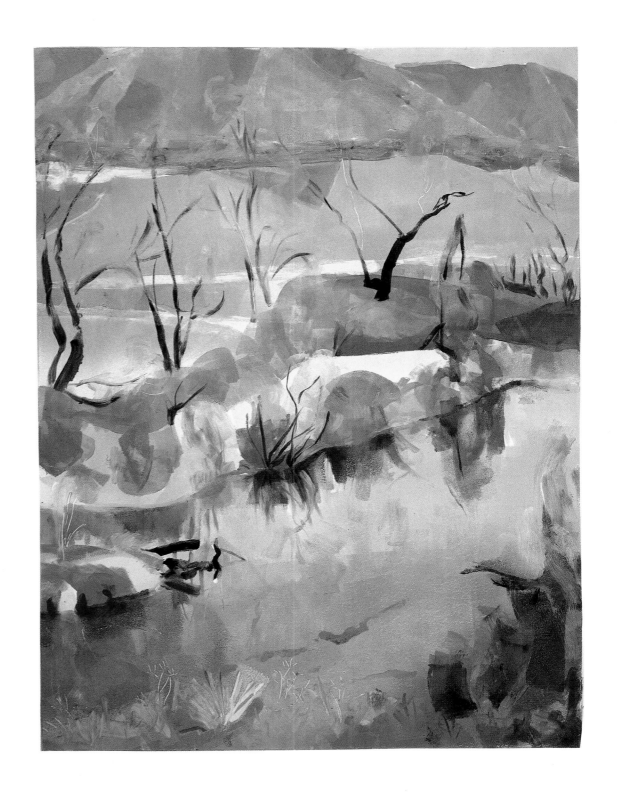

Duck Blind at Nelson's Creek III, 1994, 23¼ × 36½ inches. Courtesy Robischon Gallery, Denver

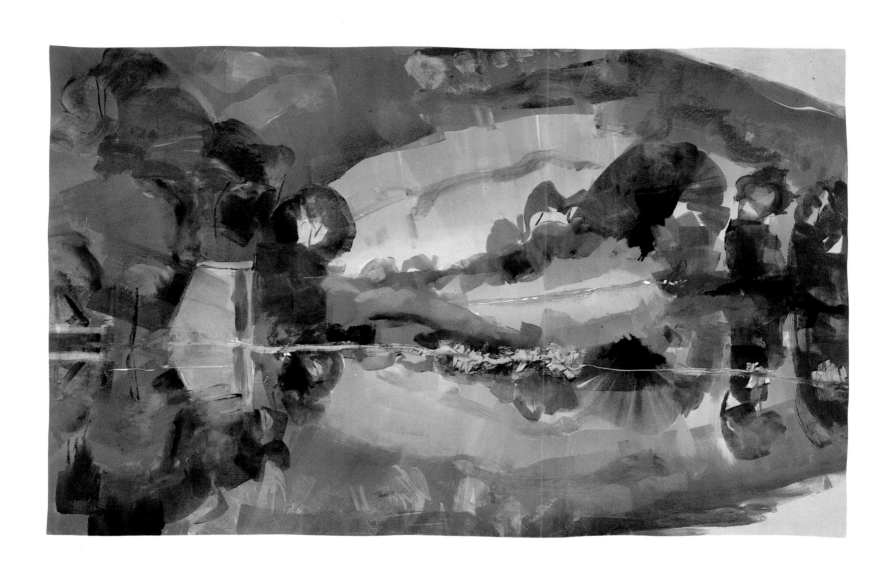

Poverty

The lament wasn't in the stiff
whips of willow or the ice-captures
of pondweed and underwater tubers,
as we expected. No moan rose
from the frost-blackened spikelets
of bluejoint or twisted cattail,
no wail from the glassy weeds
fallen, brown, prone in roadside
sheaves. Not one request sounded
in the empty, opened husks
of locust pods or the splayed
sheaths of walnuts and hickories.
The cold fog was almost blissful,
motionless, amenable among the broken
charlock and bittercress. And only
multitudes of serenities lay
in the snow-filled nests of departed
sora and wren, in the white fixations
of tangled hedges, there the purity
of the deaf, the peace of blindfolds,
the wealth of the unperturbed.

But here in this spring tumult
of magenta sorrel, here in this noisy
bee-scavenged field of wild, unruly
daisy, dewberry and rue, here is where
all despairs and frantic beseechings
wheel and ravage. Lack and longing
alike stagger and lurch in the twitching
blazes and sky-streaking screeches
of kingbirds, killdeer, bobolinks
and jays, in the gripping and mewing,
the imploring of nestlings, micelets
and kits. The beleaguered spheres above
are accosted constantly, assaulted
by these vagrant congresses of scrabbling
tongues and toes, these shakings,
tuckings and snatchings, the begging,
budding fruits of coming pokeweed,
elder, crab apple and plum. What gnashings
and furies, what demanding, pleading
heart-bombardments they all are,
each and every one crying harshly
to heaven, asking for someone equal
and mighty to come quickly
and match their passion.

Striped Fields in Spring II, 1996, 26¼ × 43¼ inches.
Courtesy Gerald Peters Gallery, Santa Fe

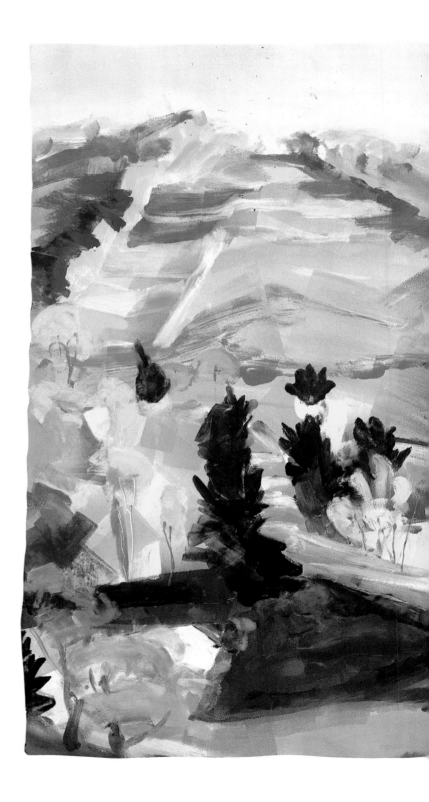

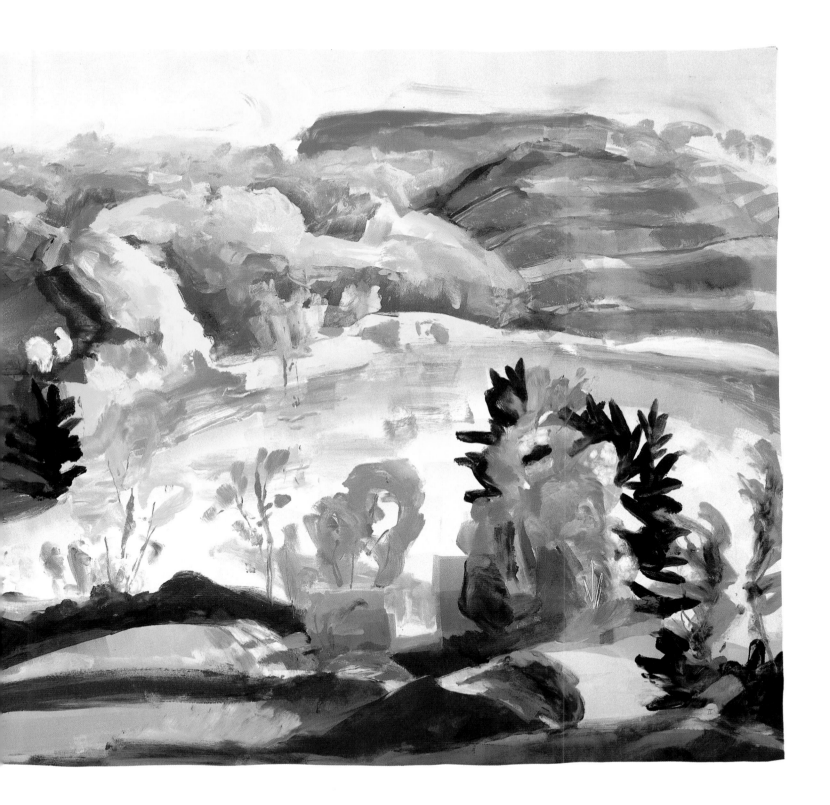

Spring on the River II, 1994, 21¾ × 29¼ inches. Courtesy Gerald Peters Gallery, Santa Fe

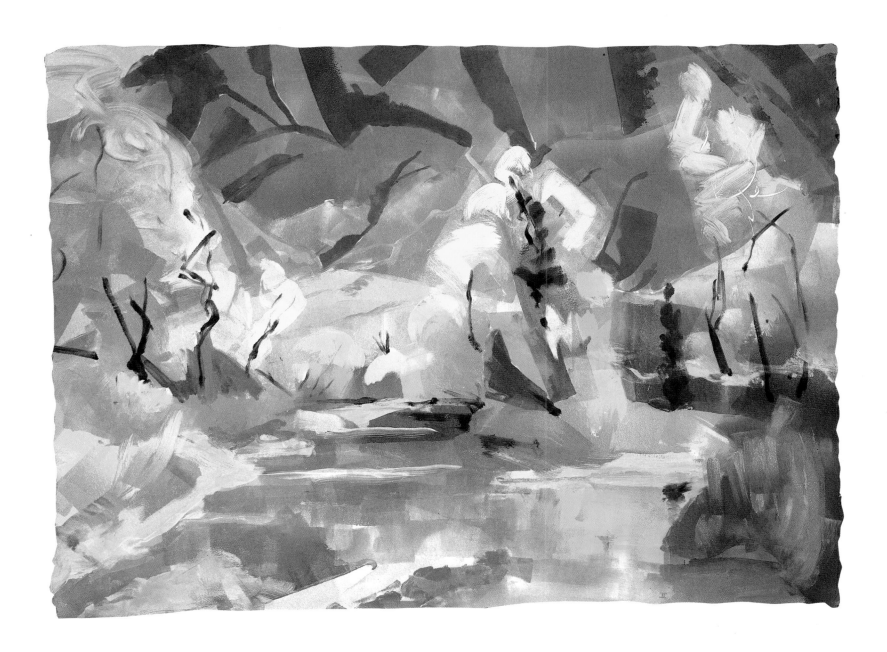

Locust Tree in May II, 1996, 26 × 43½ inches. Courtesy Gerald Peters Gallery, Santa Fe

The Loch II, 1992, 30 × 22½ inches. Courtesy Gerald Peters Gallery, Santa Fe

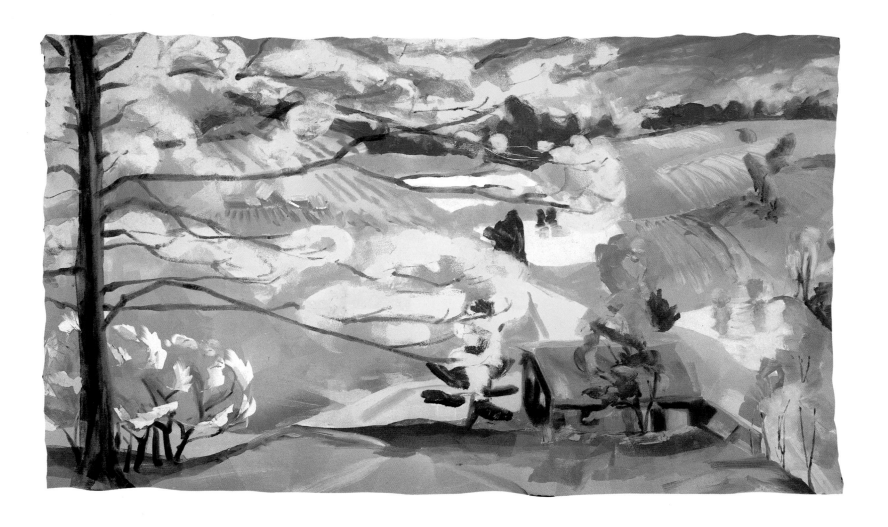

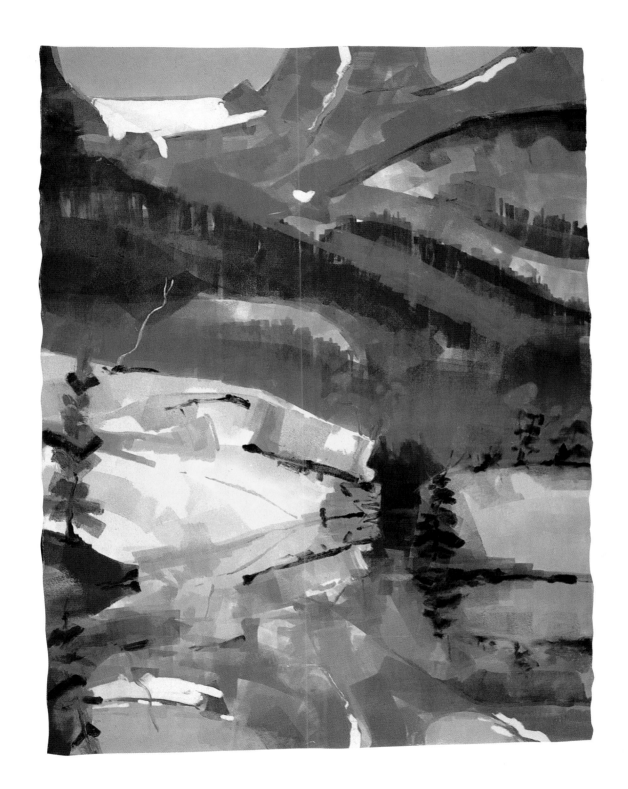

Because you

Understand This

Everything is watching you—the mockingbird,
the wood warbler, the jay, the crawfish frog,
carrion beetle, fungus beetle, the hanging fly;
everything is watching you, even the thick draw
of the tulip, the sunless center of the lidded
harebell bud, the underwater witch's nest—crowfoot,
bogbean—lungless salamander, the smallest circle
in the wound shell of the copper snail. Everything
stares. Each ring of the jingle shell, the stalk
of milk thistle, the blowing pine-needle
shadows reaching forward, forward and back,
on the stone walk, all are watching you.

Deep in its cave-stream, beneath its clear scale
and socket-skin, in its most impenetrable
unawareness, the eyeless glass fish attends,
and the tailless tenrec and the leaf-nosed
bat and the ruby mandrake in the dark
on the other side of the earth, even they,
and that which possesses only jawbone, naked
teeth in the north pasture, chipped femur,
scattered vertebrae, that which possesses less
in the commodious muck of the pondbottom,
they too keep you in focus.

Everything, even the blind retina of underground
granite, even the ocular roll
of the thunderhead, even the solid
cold lens of the gray moon . . .

Apple Tree IV, 1995, 21½ × 29 inches. Courtesy James Graham & Sons Gallery, New York

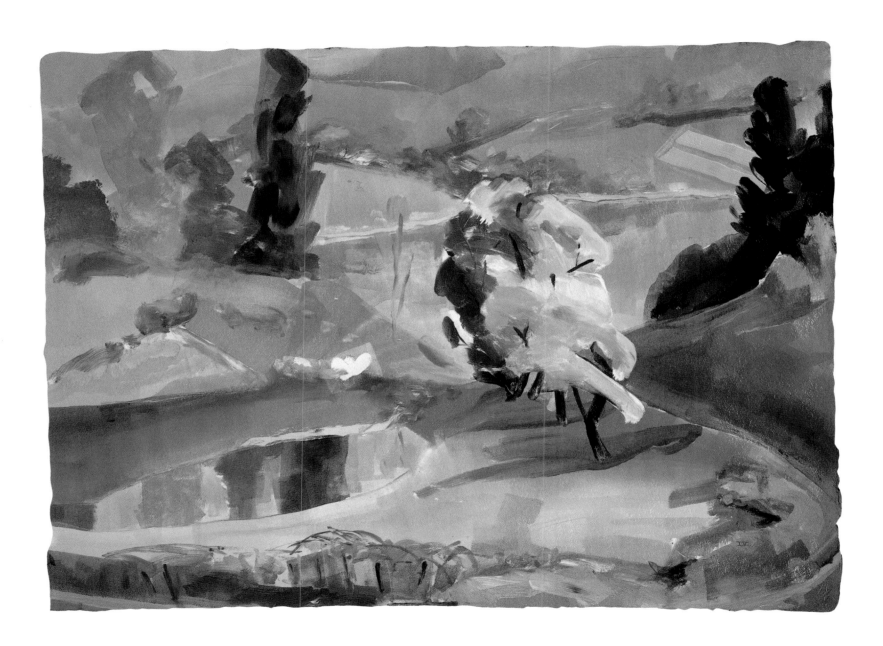

Garden in a Dinghy I, 1991, 18 × 13¼ inches. Courtesy James Graham & Sons Gallery, New York

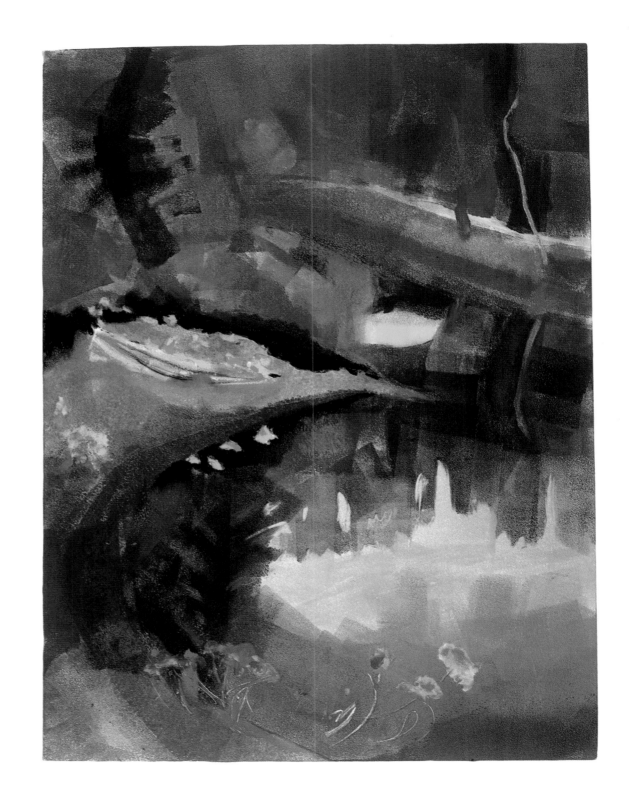

SUMMER

Maine Quarry I, 1996, 25½ × 42¼ inches. Courtesy Robischon Gallery, Denver

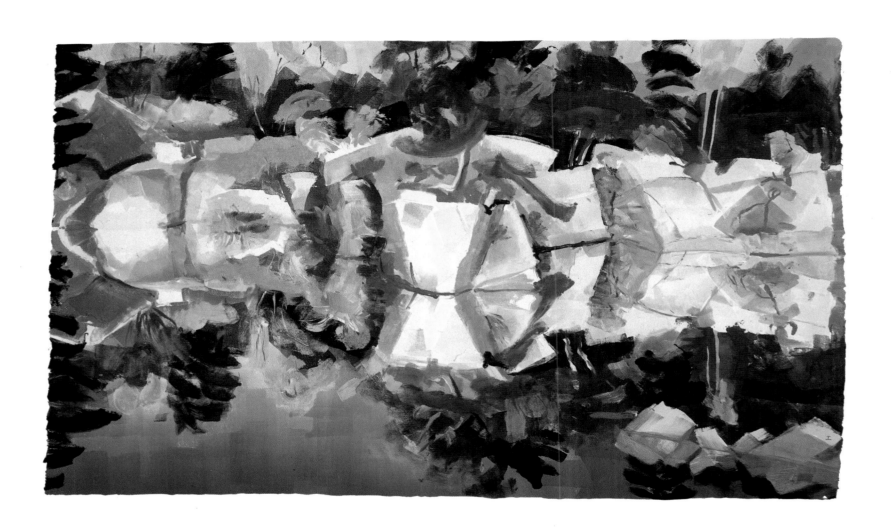

Millbrook Field in Summer III, 1992, 29½ × 35 inches. Courtesy James Graham & Sons Gallery, New York

Garden on a Cloudy Day IV, 1992, 35¼ × 23¾ inches. Courtesy Robischon Gallery, Denver

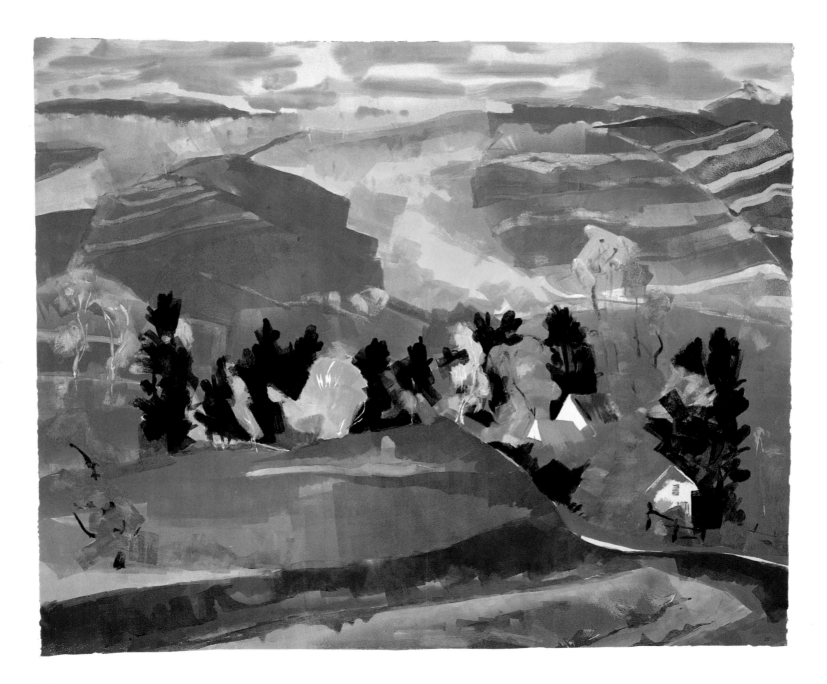

Pretty Marsh Triptych II, 1994, 33 × 45 inches. Collection of Mel and Lissa Hodder, Cambridge, Massachusetts

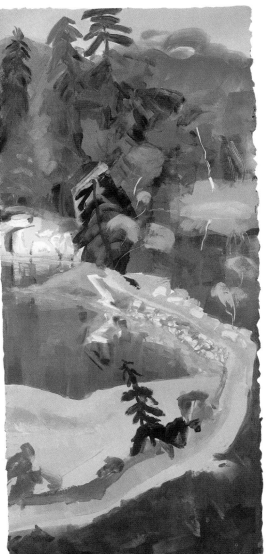

ROLLING NAKED IN
THE MORNING DEW

Out among the wet grasses and wild barley-covered
Meadows, backside, frontside, through the white clover
And feather peabush, over spongy tussocks
And shaggy-mane mushrooms, the abandoned nests
Of larks and bobolinks, face to face
With vole trails, snail niches, jelly
Slug eggs; or in a stone-walled garden, level
With the stemmed bulbs of orange and scarlet tulips,
Cricket carcasses, the bent blossoms of sweet william,
Shoulder over shoulder, leg over leg, clear
To the ferny edge of the goldfish pond—some people
Believe in the rejuvenating powers of this act—naked
As a toad in the forest, belly and hips, thighs
And ankles drenched in the dew-filled gulches
Of oak leaves, in the soft fall beneath yellow birches,
All of the skin exposed directly to the *killy* cry
Of the kingbird, the buzzing of grasshopper sparrows,
Those calls merging with the dawn-red mists
Of crimson steeplebush, entering the bare body then
Not merely through the ears but through the skin
Of every naked person willing every event and potentiality
Of a damp transforming dawn to enter.

Lillie Langtry practiced it, when weather permitted,
Lying down naked every morning in the dew,
With all of her beauty believing the single petal
Of her white skin could absorb and assume
That radiating purity of liquid and light.

And I admit to believing myself, without question,
In the magical powers of dew on the cheeks
And breasts of Lillie Langtry believing devotedly
In the magical powers of early morning dew on the skin
Of her body lolling in purple beds of bird's-foot violets,
Pink prairie mimosa. And I believe, without doubt,
In the mystery of the healing energy coming
From that wholehearted belief in the beneficent results
Of the good delights of the naked body rolling
And rolling through all the silked and sun-filled,
Dusky-winged, sheathed and sparkled, looped
And dizzied effluences of each dawn
Of the rolling earth.

Just consider how the mere idea of it alone
Has already caused me to sing and sing
This whole morning long.

Alaskan Waterfall II, 1991, 12 × 18 inches. Courtesy Gerald Peters Gallery, Santa Fe

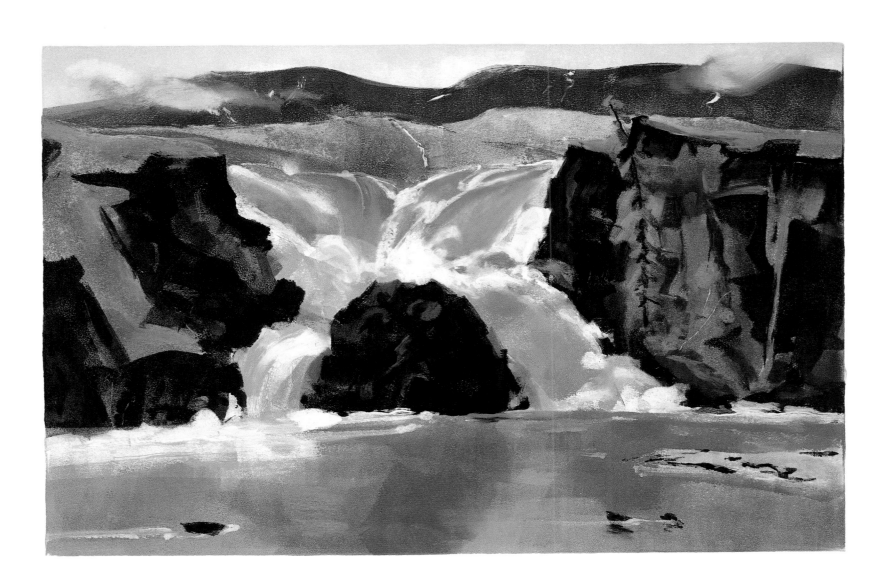

Mount Desert from Calf Island, 1996, 27 × 63½ inches. Courtesy James Graham & Sons Gallery, New York

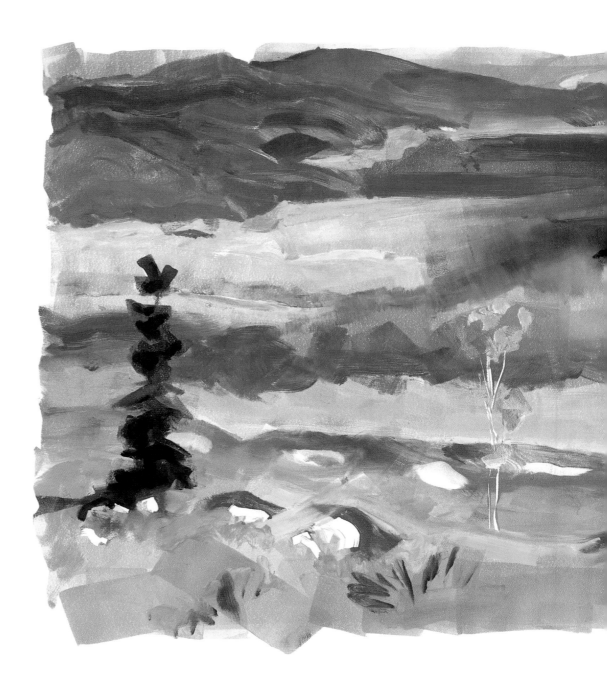

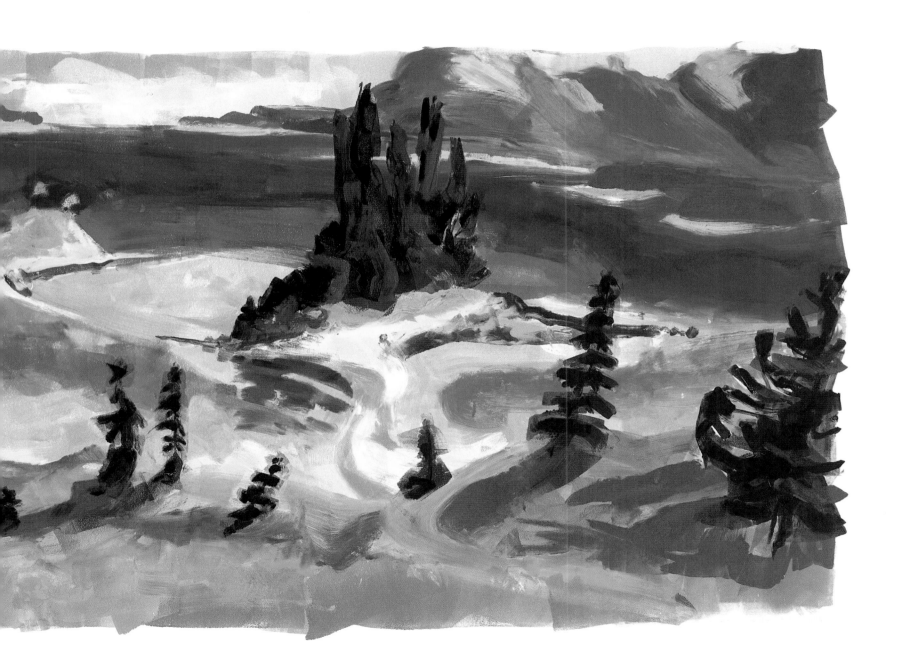

Orchard at Goose Cove, 1993, 8½ × 20 inches. Courtesy James Graham & Sons Gallery, New York

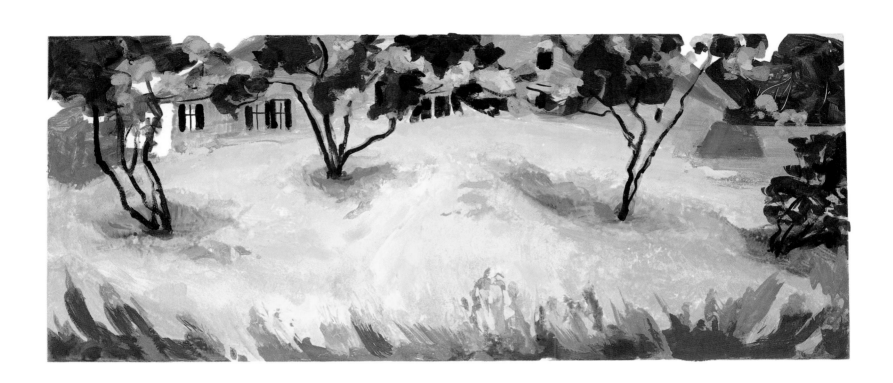

SUMMER SOLSTICE

When I was very, very fat, rotund
with hot hills and valleys, deep with purple
crevices and vapors, my belly a sizzling
horizon over which I could never see,
I sat on the old front porch on a patched
cushion, my puffed hands folded
across my steaming breasts.

I was bronze as a sun in those days, shining
with perspiration which often ran
like rain down the gully of my back, fell
occasionally toward evening in drops
like stars from my forehead.

Winter then was just a lacework
of bones, hardly a consideration
of skeleton buried deep and hidden
inside my bubbling and swirling,
my sweltering seethe.

I lay back, sank into my own blaze
and dozed, humming and snoring,
stirring a toe now and then, a twitch
of nose, all my keys turning, all my tressy
locks unlocked.

A citizenry of bumbles, a fiesta
of dragonflies in match-blue, in struck-gold,
whirled and hovered, pricked and darted
constantly about my girth. What a commotion
of blackbirds and flower pods rose
when I rumbled at noon, shifting slowly
from one gargantuan hip to the other.

I was so finely gorged, so beautifully
satiated. I sighed, pleased, rocked
and fantasized in the sheer breadth
of my own breathing, while one cool
green bead of bayou tree toad perched
crooning, lullabying low on the lip
and delve of my sheltering ear.

Maine Cove with Nasturtiums, 1996, 27½ × 64 inches. Courtesy Robischon Gallery, Denver

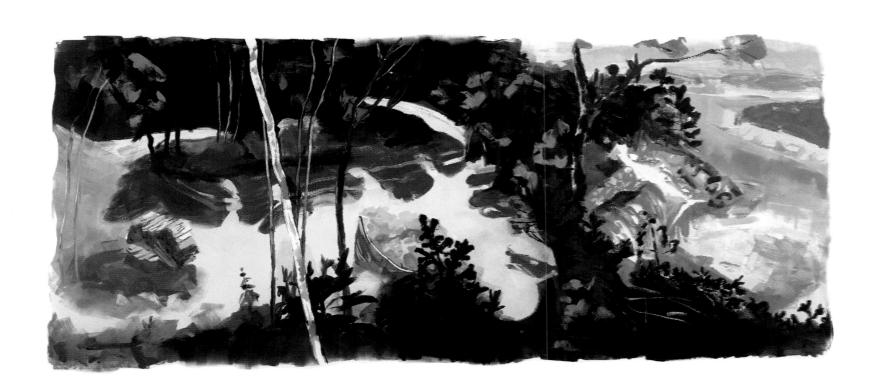

Shaded Lilies IV, 1994, 15¾ × 21¾ inches. Courtesy Gerald Peters Gallery, Santa Fe

Mountain Lake and Garden II, 1992, 23½ × 19½ inches. Courtesy Robischon Gallery, Denver

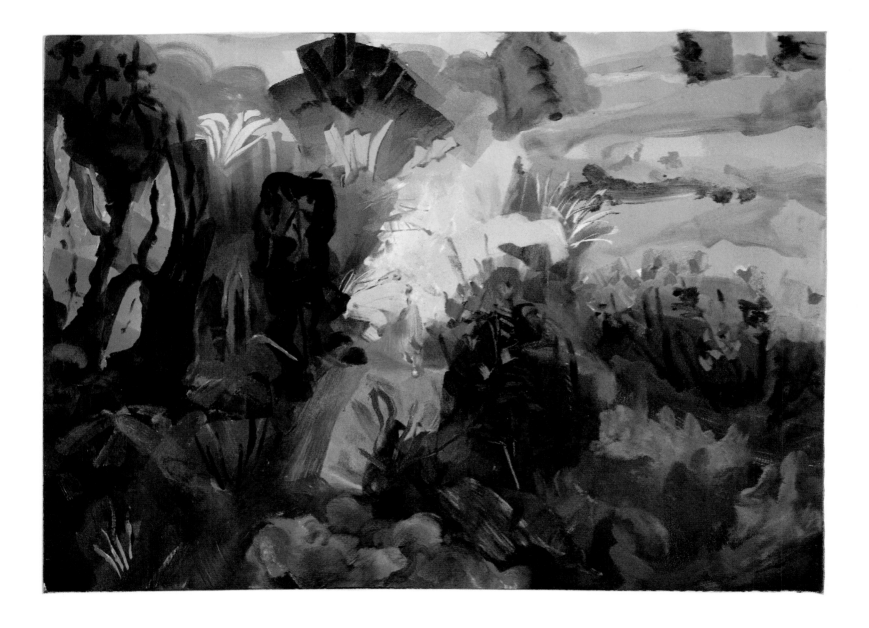

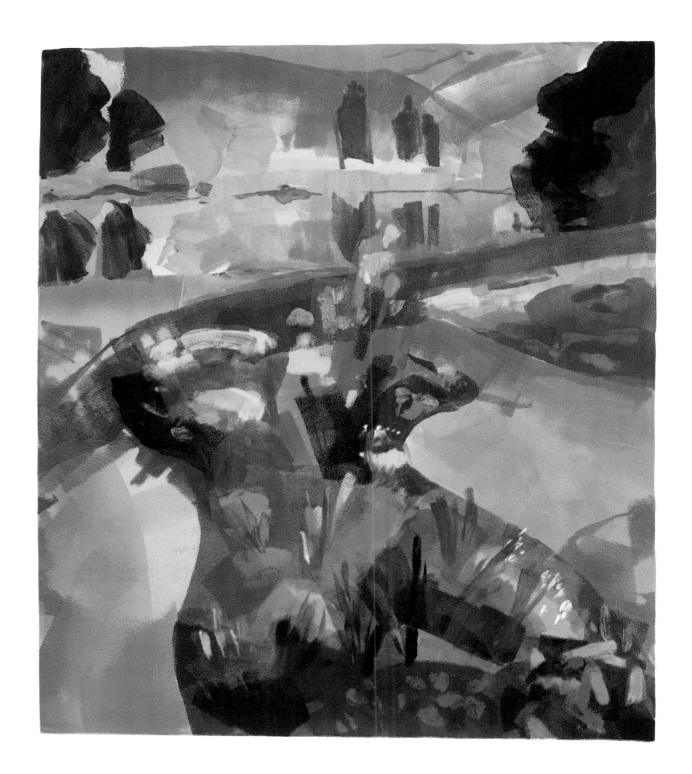

MY BRIDES

They are shaggy bulbs of beetles
buried under dirt rocks of ice.
They are green silk moths

of seeds carrying the orange
burnings of their own lanterns.
They are the gatherings of the harsh

salt-roll and lay of sea eggs
nested in knots beneath the horizon
offshore. They anticipate

like the light speaking inside late
summer grasses before the first
sound of dawn. They forswear

like blood in the wing
before the prairie finch rises.
They possess like the windows

of stars unlocked, unlatched, lit
all night long across the maps
of their sleeping cities.

They shine like the skin of white
covering the stone bellies of the dry
river bed, like the hips of the unseen

blue-white glow of the black new
moon. I myself have promised myself
to their promises. I wait

with sterling rings and testimonies,
with abodes, with witnesses. The bonds
are signed and published.

Highest Tide in June I, 1992, 15½ × 35½ inches.
Courtesy James Graham & Sons Gallery, New York

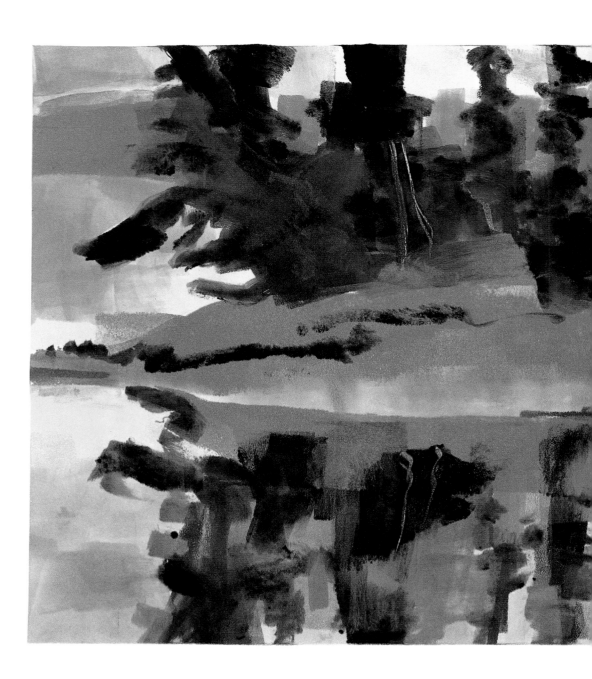

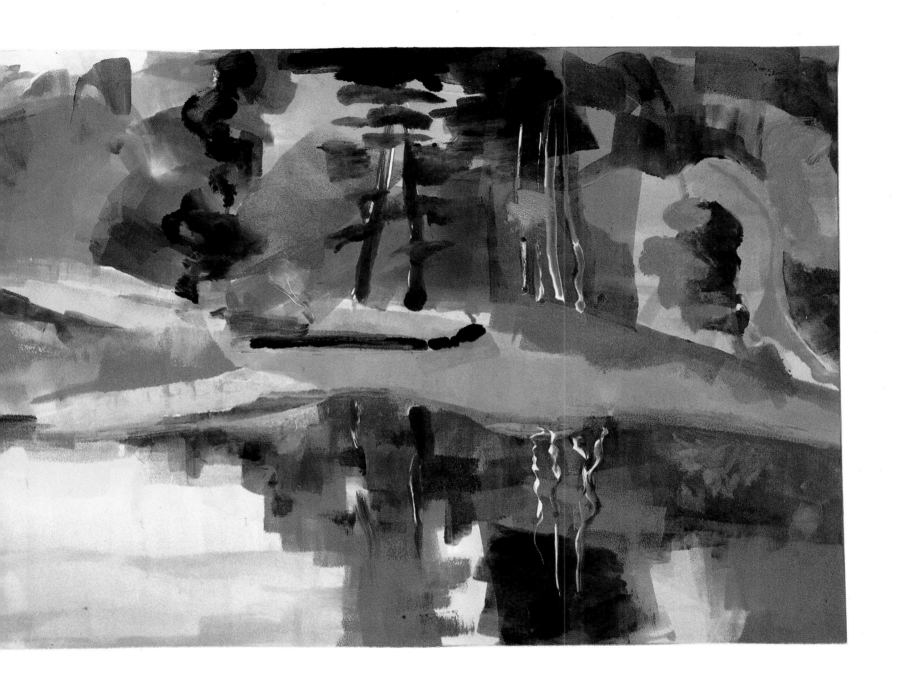

Folly Island Evening III, 1992, 22½ × 26½ inches. Collection Helen and Paul Anbinder, New York

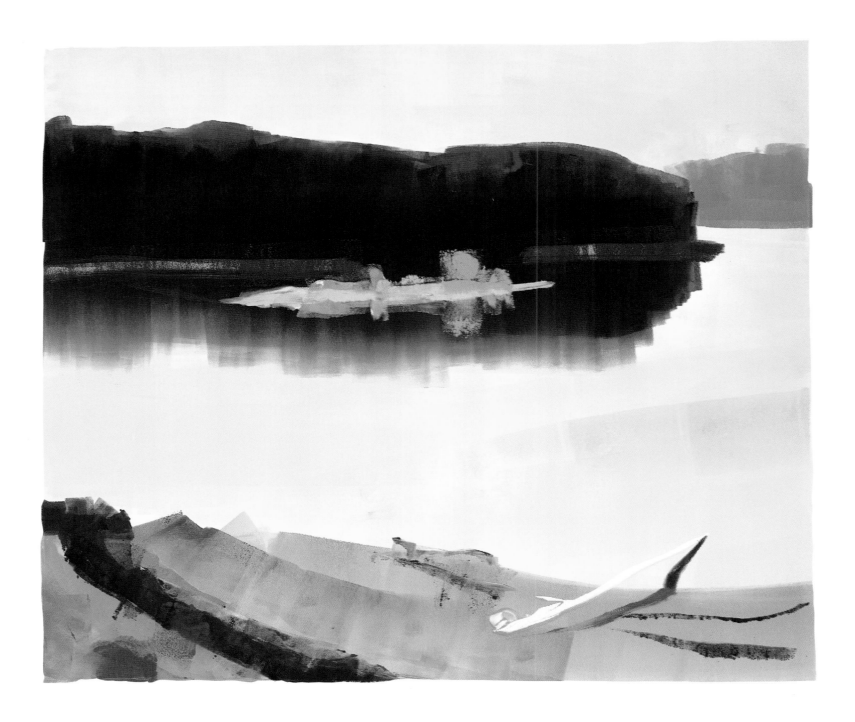

Autumn

September Morning, Middleburg, Virginia, 1997, 25¾ × 33½ inches. Courtesy Gerald Peters Gallery, Santa Fe

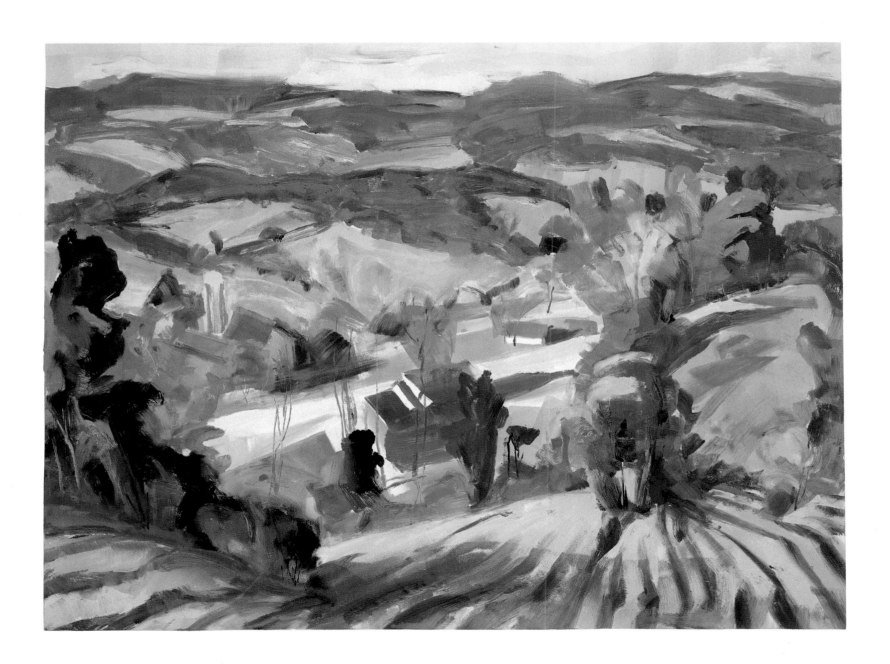

Wetlands in Autumn V, 1994, 17¼ × 20¼ inches. Collection of Tom Edwards, Freeport, Maine

Above Three Waterfalls IV, 1993, 25½ × 20 inches. Courtesy James Graham & Sons Gallery, New York

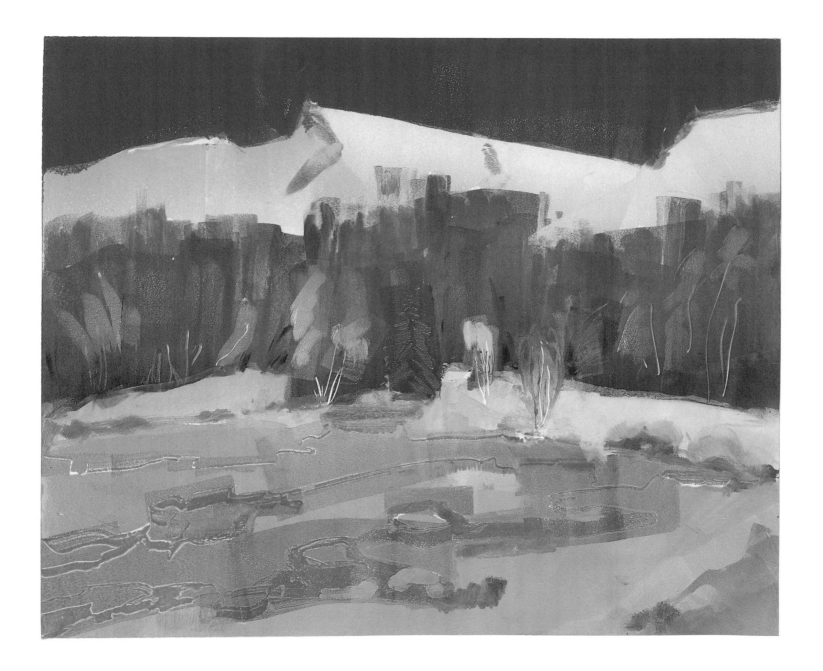

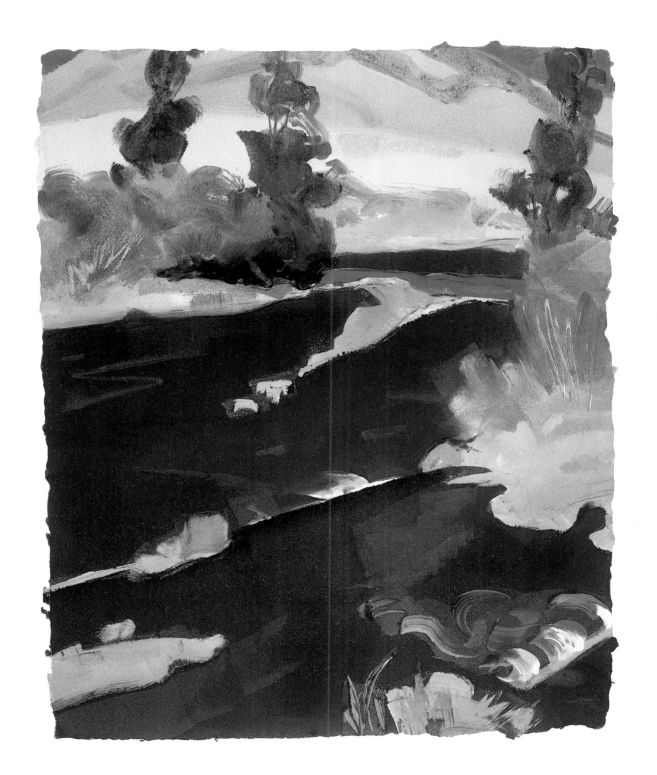

OF POSSIBILITY: ANOTHER AUTUMN LEAVING

Here they come like miniature herds
of headless ponies without hooves,
stampeding, rearing, trampling one another.
They corral to circle upward themselves
like air-borne droves of crippled brown
crows, rising in fragments of dust spouts,
raining down singly in swiveling pieces.

As if they were blind, they batter
against barricades, pile along brick
walls, boulders, wooden fences, filling
gullies and clefts, multitudes deep
as if they had no need to breathe.
Even with bodies without lungs,
there's a ghost cusp and sigh, a hollow
desert buzz to their rousing.

They sweep all night in the dry-moon
rasp of their rattling trance.
They scutter and reel up the window panes
on their hundred pins, over the roof
in their thorny flocks. Though totally
lacking bones or the tatters of bones,
still they shrivel and quake.
Though totally devoid of hearts
or the rubbish of hearts, still
they are brittle and heedless.

Even without souls, they shiver and rend.
Even without devils, they make ritual
processions of their deprivations. With no
word at all, they lie. They stutter.
They testify to themselves. Even lost
and without a god, they make visions
of the invisible, become the buffet,
the possessed, the very place of wind.
They are the time and tangible nexus
of all heavenly spirits. Even without tongues,
they clatter their tongues.

Orchard and Arroyo II, 1996, 9½ × 19½ inches.
Courtesy Robischon Gallery, Denver

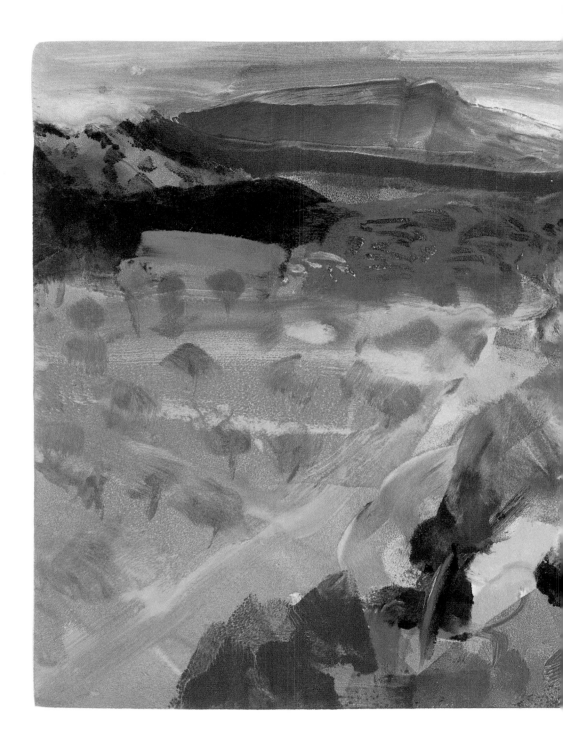

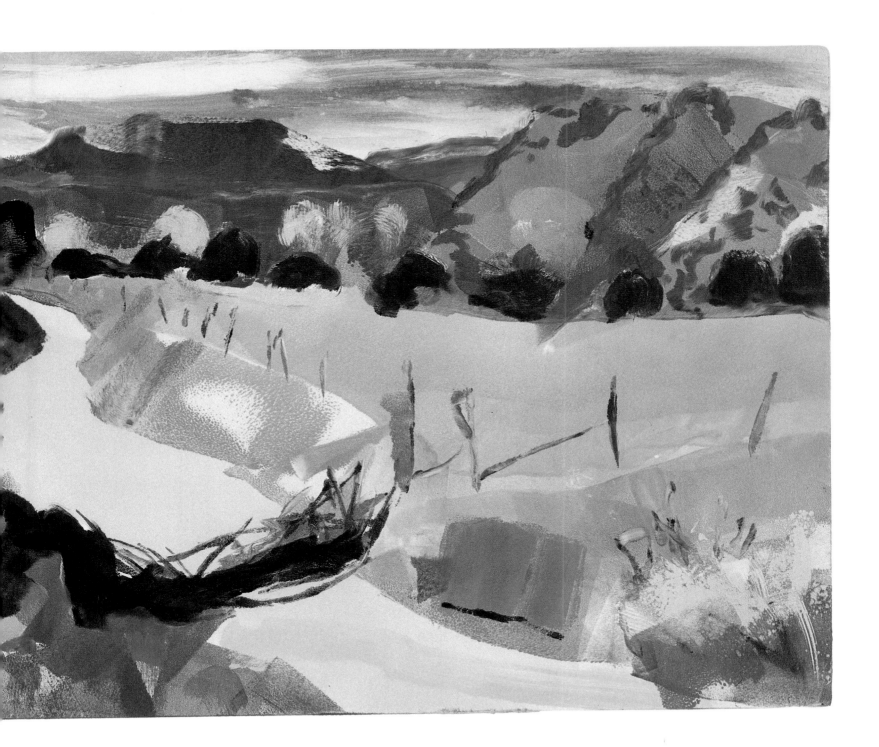

Chama Triptych, 1997, 74½ × 60 inches. Courtesy Gerald Peters Gallery, Santa Fe

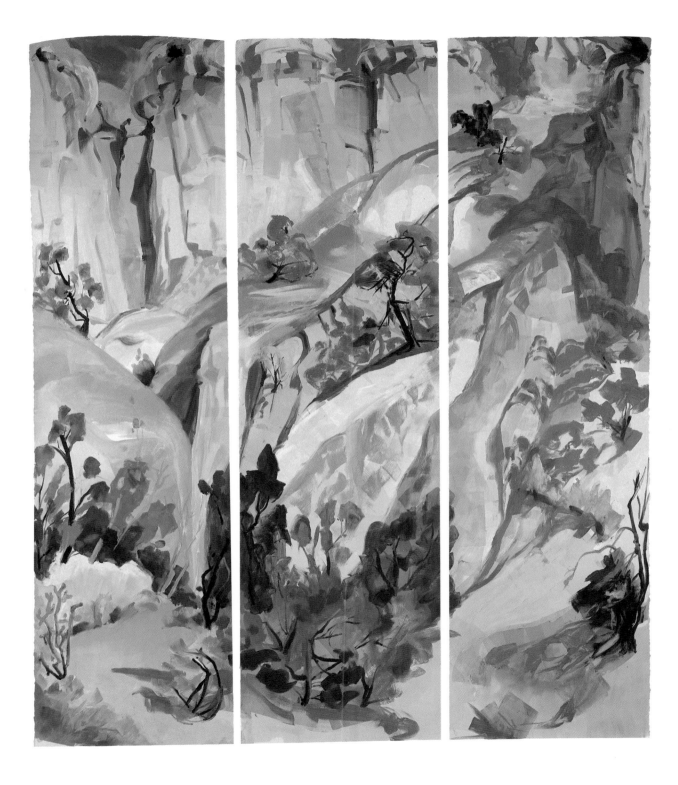

Cottonwood Tree, Autumn I, 1996, 16½ × 17¾ inches. Courtesy Robischon Gallery, Denver

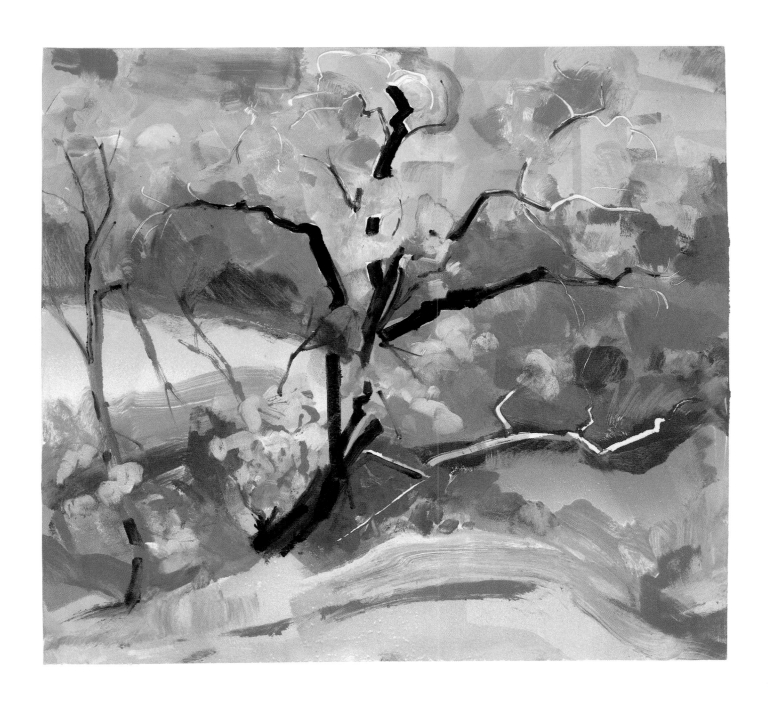

River in Autumn II, 1991, 22¼ × 22¼ inches. Courtesy Gerald Peters Gallery, Santa Fe

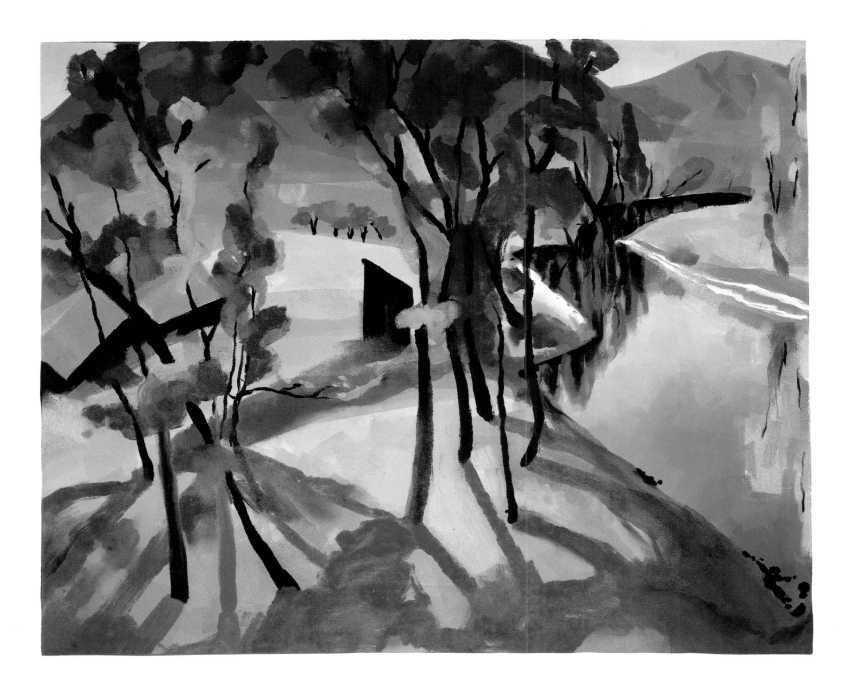

LANGUAGE AND

EXPERIENCE

I consistently confuse the marsh frog
with the purple pitcher plant.
Maybe it's because each alike makes
a smooth spine of the light, a rounded
knot of forbearance from mud.

And which is blackbird? which prairie thistle?
They both latch on, glean, mind their futures
with numerous sharp nails and beaks.

Falling rain and water fleas are obviously
synonyms, both meaning *countless*
curling pocks of pond motion.
And aren't seeding cottonwood laces
and orb weavers clearly the same—clever
opportunists with silk?

I call field stars and field crickets
one and the other, because they're both
scattered in thousands of notches
throughout the night. And today I mistook
a blue creekside of lupine for *generosity,*
the way it held nothing back. O reed
canary grasses and *grace*—someone tell me
the difference again.

Write this down: my voice and a leaf
of aspen winding in the wind—we find the sun
from many spinning sides.

Cliff Face with Cottonwood IV, 1995, 29¾ × 21¾ inches. Courtesy Robischon Gallery, Denver

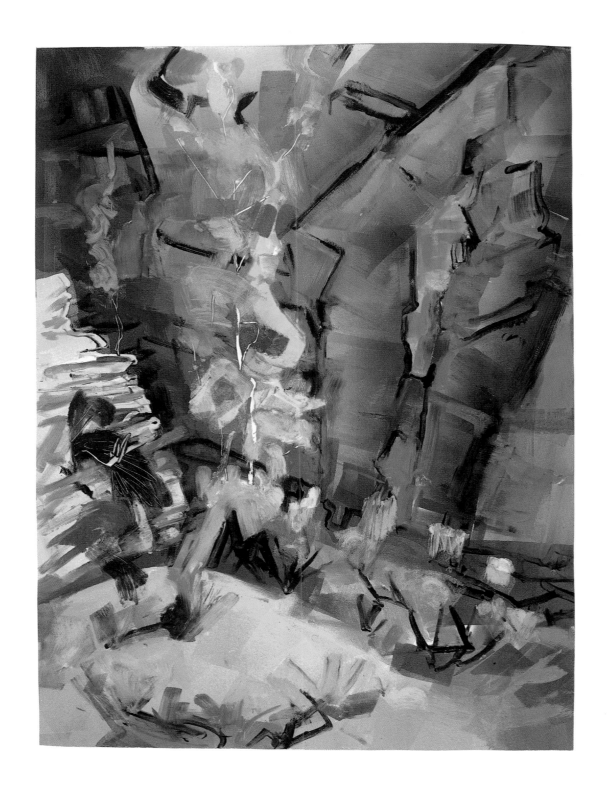

Passing Storm III, 1992, 30 × 44¾ inches.
Courtesy James Graham & Sons Gallery, New York

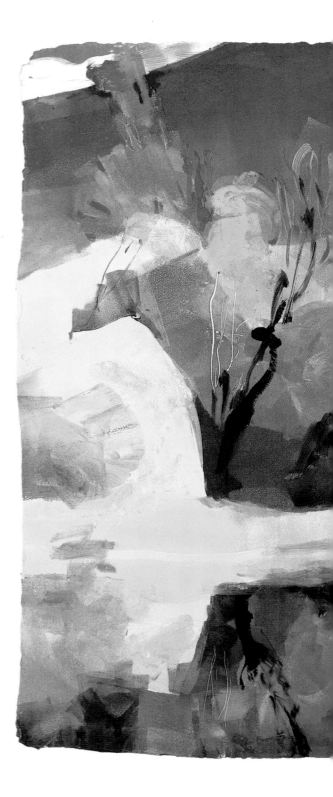

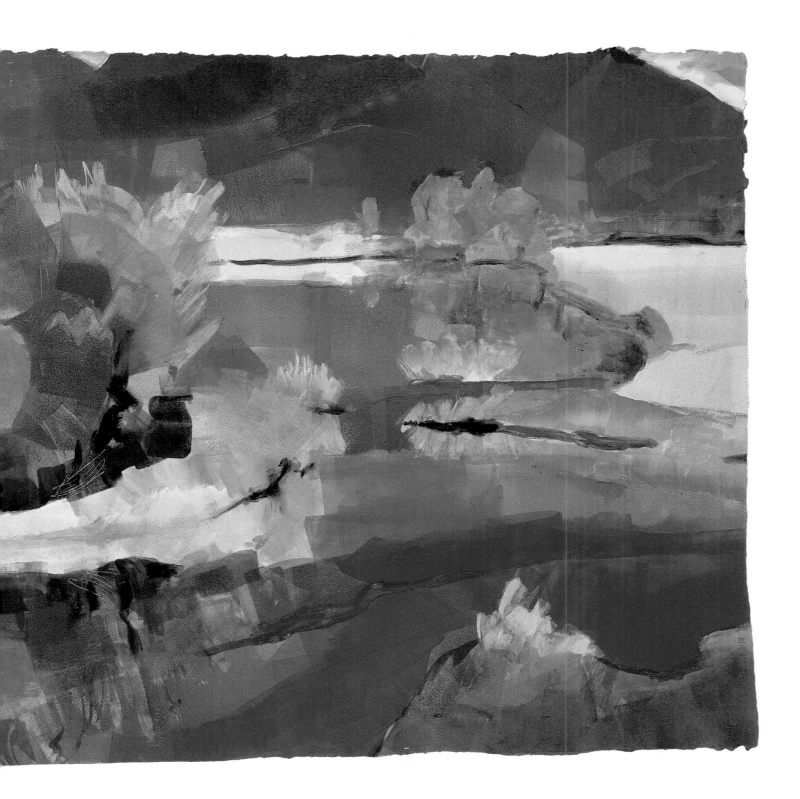

Buffalo Pass, October III, 1992, 23½ × 31¼ inches. Courtesy Gerald Peters Gallery, Santa Fe

Quarry on the Front Range II, 1992, 30 × 22½ inches. Courtesy Robischon Gallery, Denver

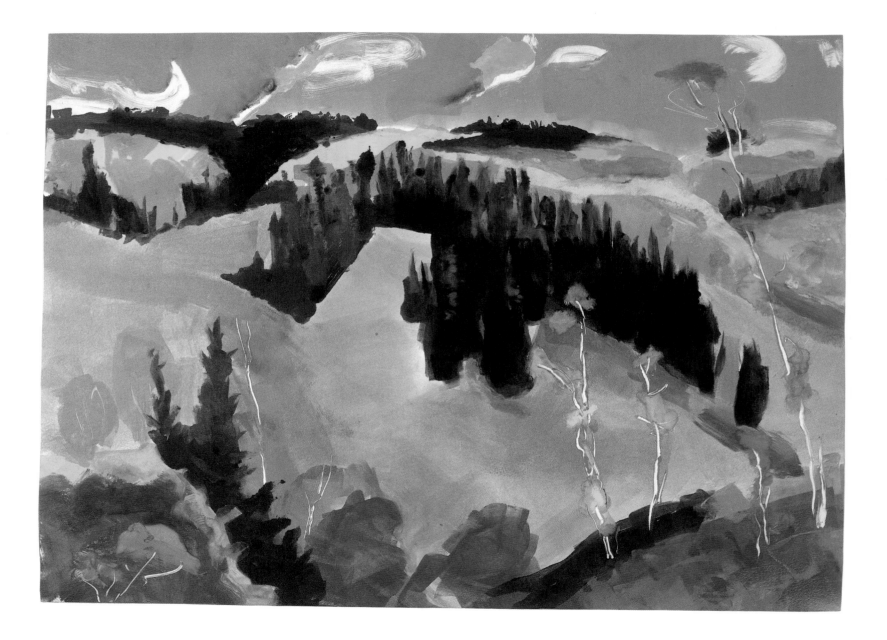

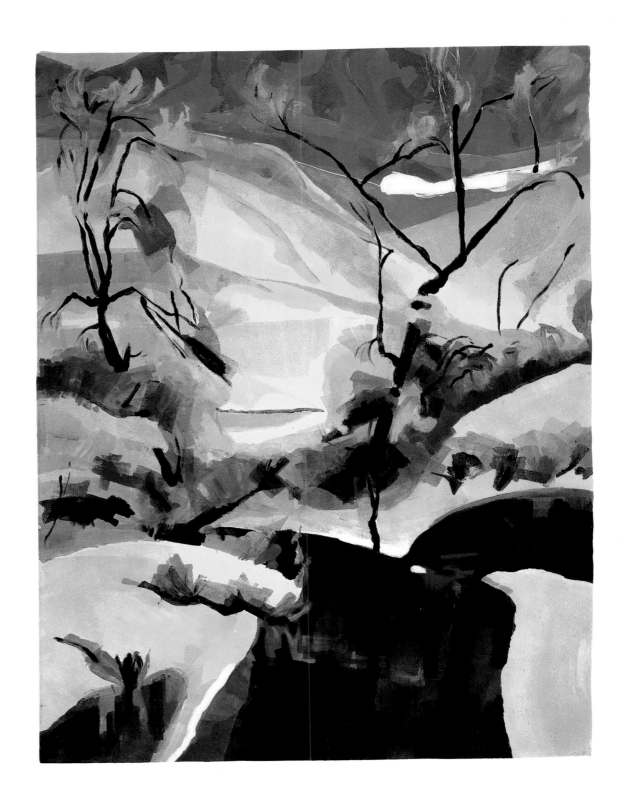

FIVE DIVINITIES
OF RAIN DURING SLEEP
ALL NIGHT

I

Turning once during sleep, I was certain
the rain was present. I might have perceived
a glinting measure of it then, like glimpsing
a gray slant of wing, an arc lost immediately
in all the flying lines of the forest,
never comprehending the weights and graces
of the entire creature itself.

II

And once after midnight, asleep,
I know I assumed the resonance
of rain particled among the poplar
leaves. I took in that quiet percussion
under my quilt, under my gown,
into my breastbone, into the smallest
bone-sliver of audibility I possessed.
It rang there, many sided, hanging
with the same faltering cadence
found at the edges of star clusters
where neither rain nor tree nor
breastbone are ever found.

III

I turned over. This is the way the rain
is sometimes during sleep: a shroud
the body knows is descending, shredded
and surfeiting and slow, so slow
in settling, never quite arriving
to cover and stop completely the mouth
and nose and eyes with a pressure
the body comes to wish for, a smothering
motion that sleep, even without a will,
longs to imitate.

IV

All night I became the rain, multiple,
rolling over and over easily
off the roof edge, burning silver
and crooked on the glass outside,
wavering down through thunder, through
a theory of sky, down from the black
clouds, having possessed, before falling,
the moon in its shearing clarity high
above the other side of the same clouds.

V

I almost remember having the rain
in my arms in bed last night, knowing
its real name finally, calling its real name
with its own tongue, pulling it down
and down, saying *god* once, sinking
with it piece by piece into the earth,
just the way we both always wanted.

Red Cliff in Autumn I, 1992, 26½ × 22¼ inches. Courtesy Robischon Gallery, Denver

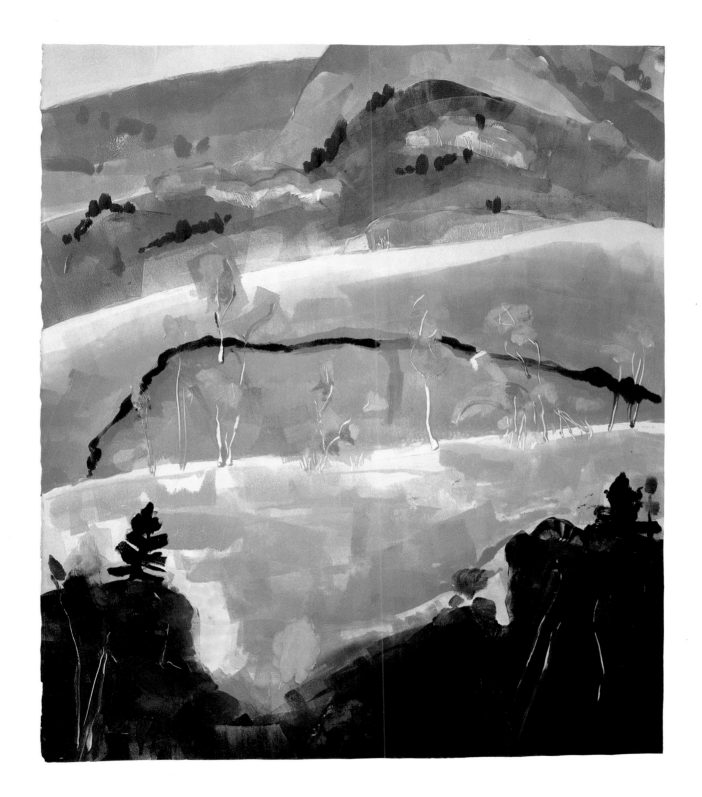

Winter

River Ice IV, 1994, 36¾ × 22¾ inches. Courtesy Gerald Peters Gallery, Santa Fe

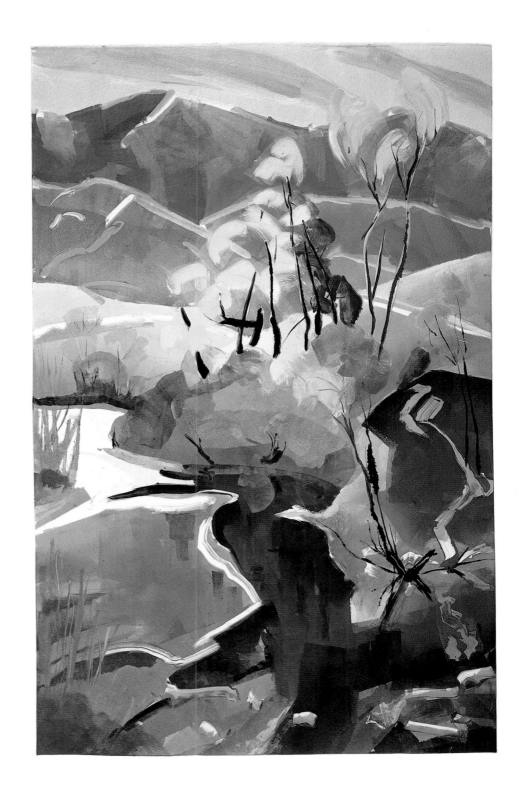

Cattails in Winter III, 1994, 23½ × 34½ inches.
Collection of Gaylord Neely, Washington, D.C.

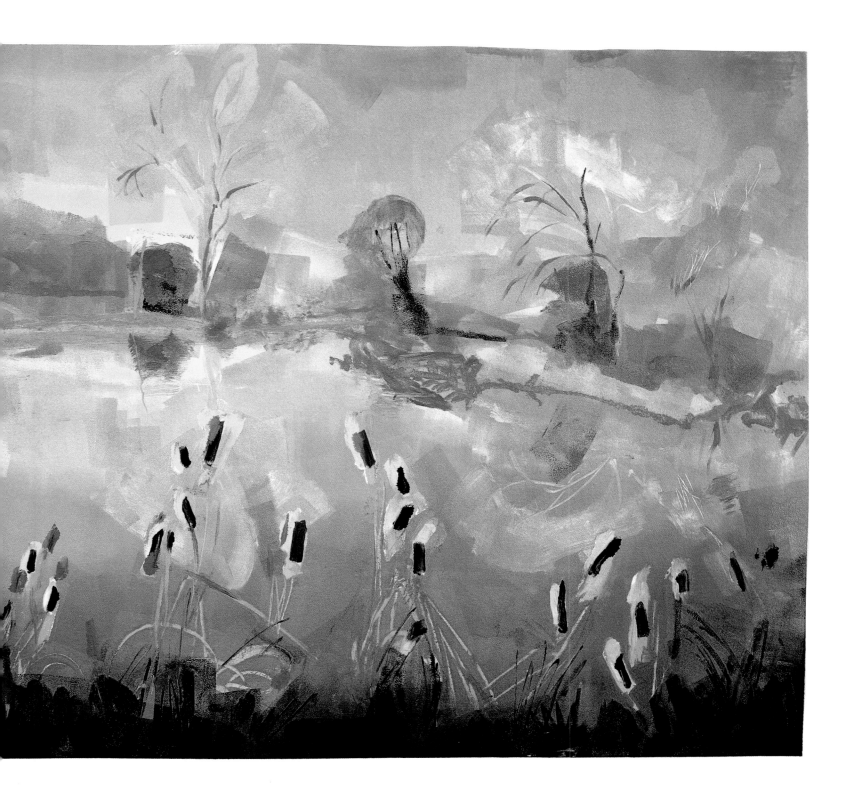

Birch Tree III, 1991, 18 × 12 inches. Collection of Randall Ash, Denver

Arroyo in Chimayo, Winter IV, 1993, 32½ × 22½ inches. Courtesy Robischon Gallery, Denver

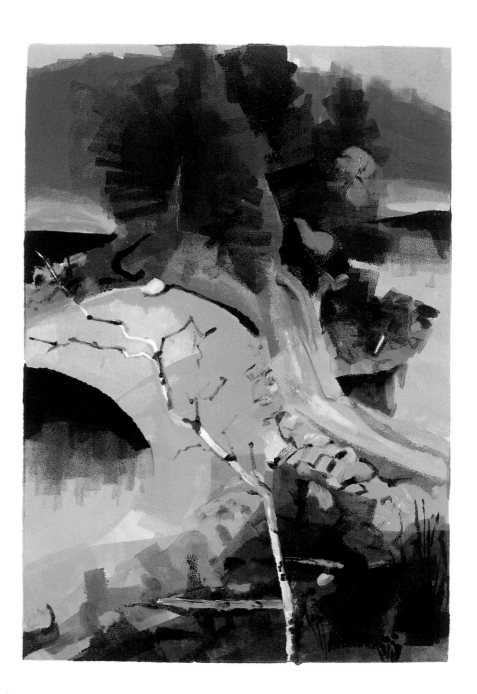

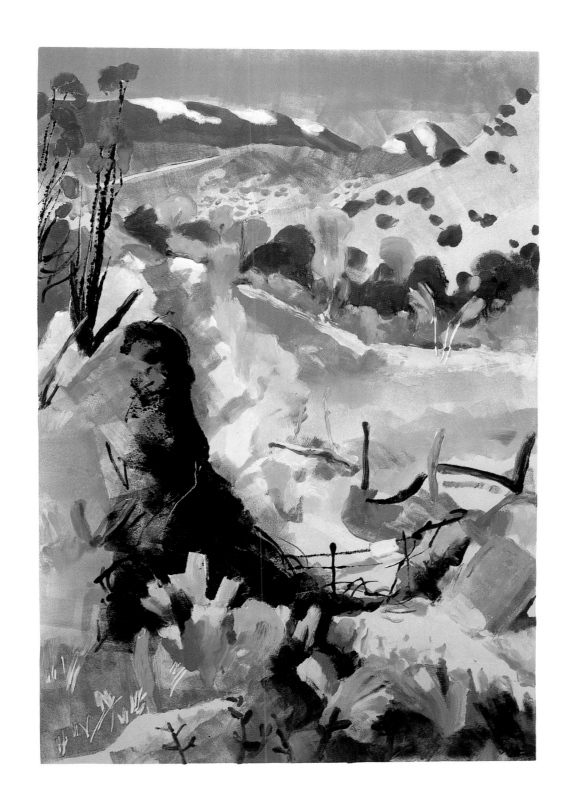

*J*ANUS

This is the body we know:
the one prolific with seeds, seeds
with translucent wings veined like dragonfly
wings, peach pits and poppy peppers,
seeds cradled in pods, emboweled
in birds, sky-flocking seeds of threaded
down looking like dixa midges circling
midair, swimming seeds with tails
like whips, seeds with teeth, seeds
with caskets, migrating seeds of needled
burrs and thistles, seeds like bits of ash
burning through the evening like flecks
of stars, and the dust-size seed of death
born in every heart coming to light.

This is the body we know:
the one moon-sterile, barren white
and barren black, bouldered with the frozen
rocks of dry polar plains and dusty drifts
of bristled snow, with gray, ancient
forests of fallen stone trunks and fronds,
littered with smoldering metal, shattered
meteors and melting iron, fossilized
spines and splintered bones, eyes locked
open and sightless in chunks of amber,
impotent, broken penes of marble, cracked
eggs of solid granite, and the rock-
permanent light of the heart born
in every seed rising to death.

Pedernal and Snowfields III, 1992, 25 × 34 inches. Collection of Nancy Lake Benson, Denver

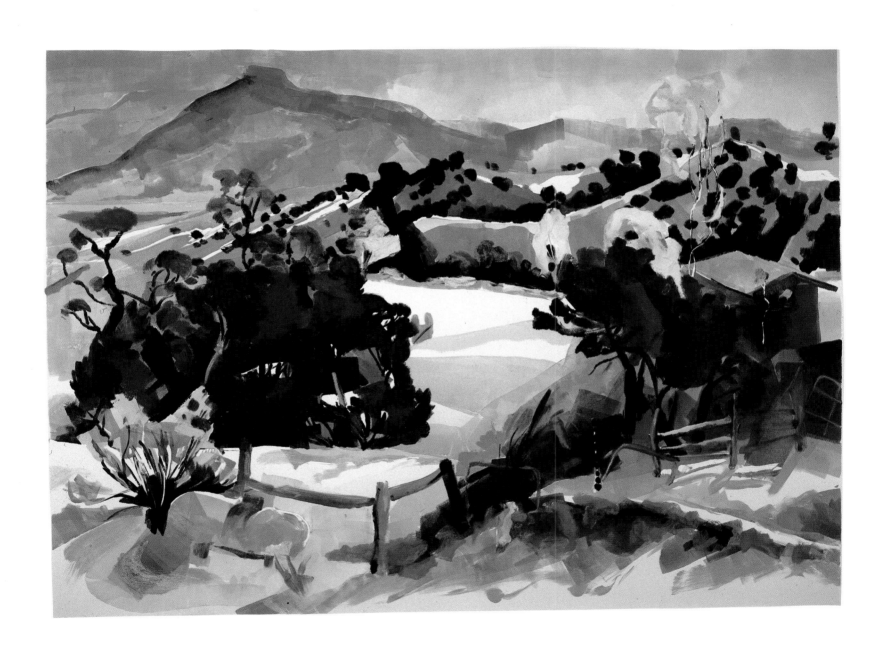

Creek in a Red Canyon V, 1992,
30 × 22 inches.
**Courtesy Gerald Peters Gallery,
Santa Fe**

Frozen River IV, 1991, 30 × 22½ inches.
**Courtesy James Graham & Sons
Gallery, New York**

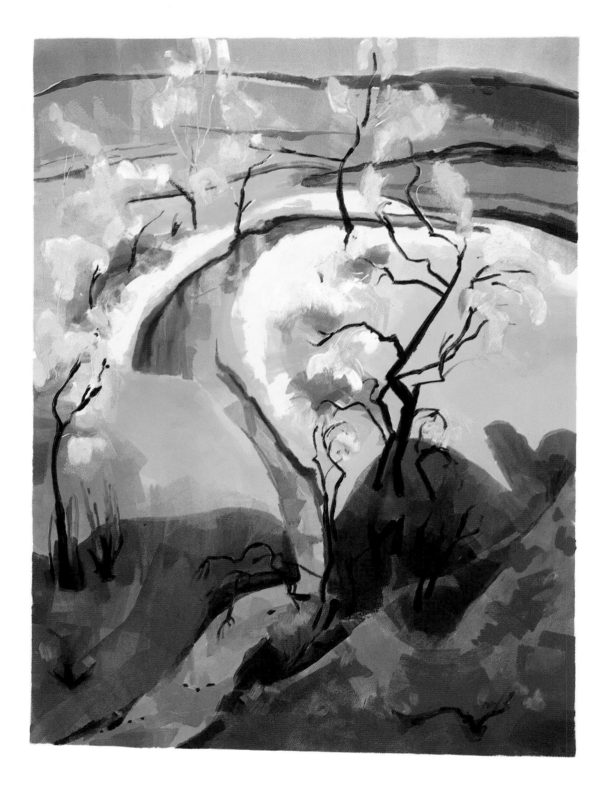

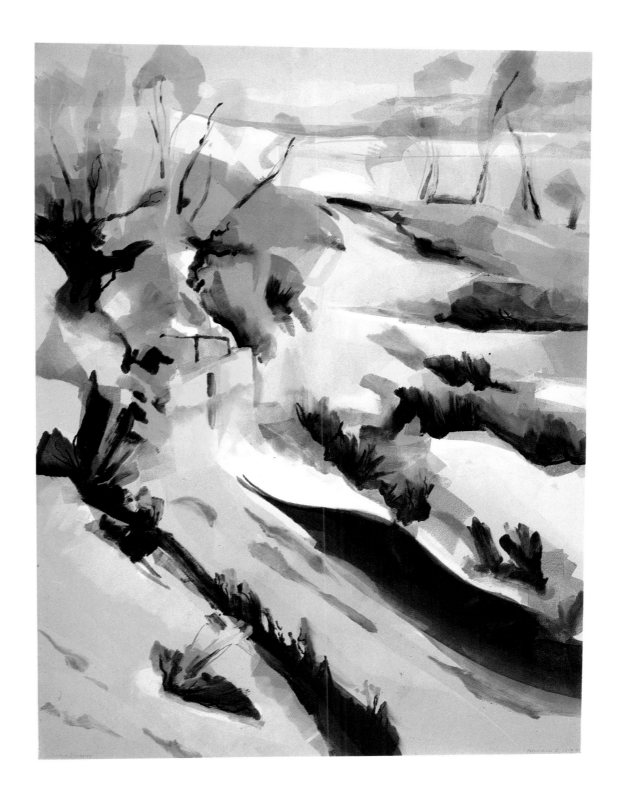

WINTER FISHING

I can see them through the ice—
large-bloomed orchids and red cannas,
bluebirds, foxes, new-bulbed
nectarines on branches. They roll
in a tangle—the puffed ducks with flossy
green heads, the red peppers, snakeweed,
lizards, passion flowers—all caught up
in a current, bound together in slick
tendrils, umbilicals, root ropes.

They're luscious. Some sink, some slip
by me sailing the surface to disappear
momentarily in their mélange, to re-emerge
tumbling in a welter like a churning
thunderhead. What a season they make.

But all I catch are glimpses of otters rutting,
weasel lays, purple beetle shells, ant-egg
pearls, posing pearl-eyed frogs, lips
around a piping, a hand trailing
a scarf on a ring.

Smart and elusive, they're there.
I can see them through the ice, my blue hands
spread against the rigid frost. I watch now
a hard-honey nougat of moon hiding
as it rises through capes and blinds,
past curtains of blossoming limbs
and cords, until it is stopped, pressed
like a sunbathed face looking straight at me
from its side of the cold, cold glass.

Island in a Dry Riverbed II, 1992, 29½ × 41½ inches. Courtesy Gerald Peters Gallery, Santa Fe

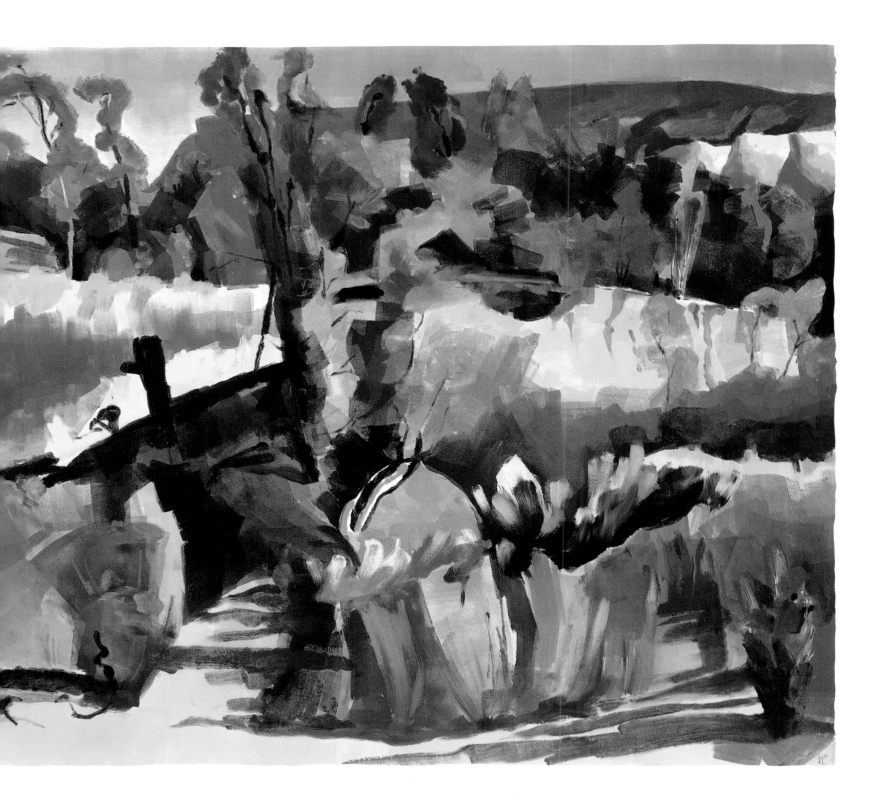

Beach at Sundown VI, 1995, 36¼ × 23¼ inches. Courtesy Gerald Peters Gallery, Santa Fe

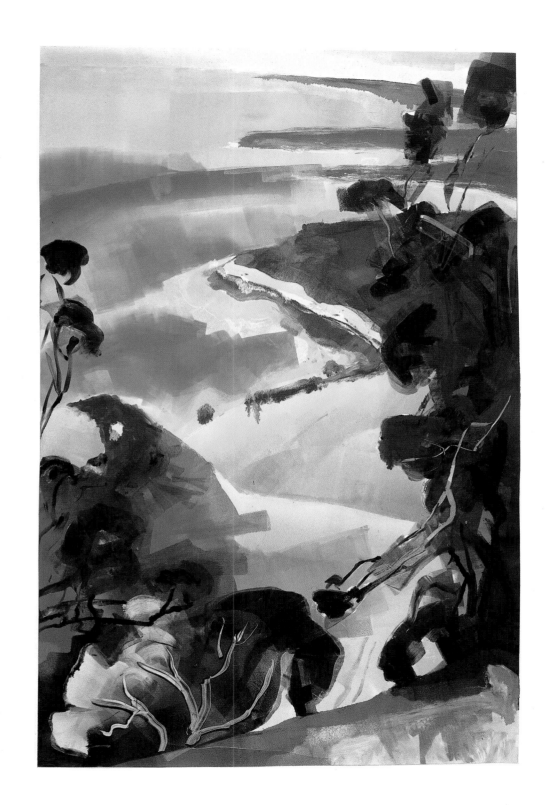

Mimbres River, Winter II, 1992, 31 × 23¼ inches. Courtesy James Graham & Sons Gallery, New York

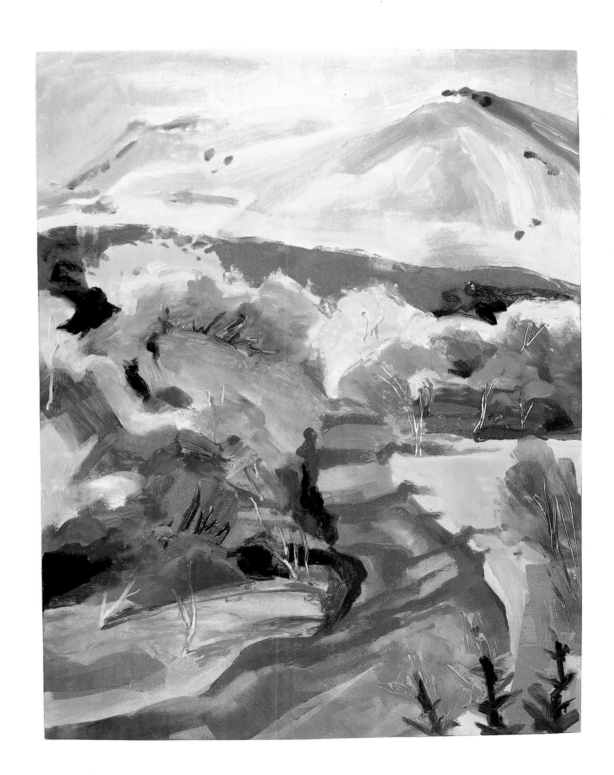

Melting Pond Ice VII, 1993, 27 × 20 inches. Courtesy Robischon Gallery, Denver

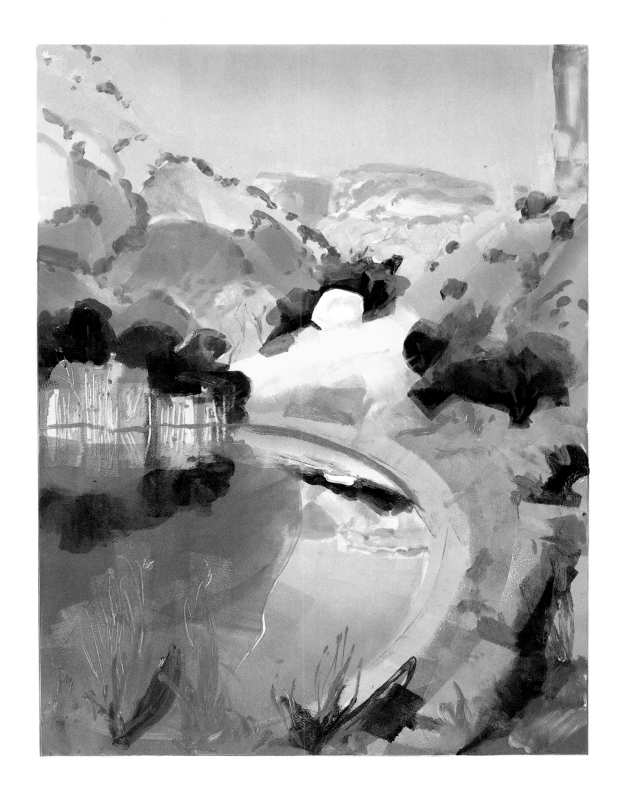

WINTER MATCHES

I
Walking Home through a Whiteout

Many crippled angels attend me here,
hovering on all sides. My breath,

the same color as this storm, floats
through their snow-filled wimples,
swirls their gauzy pantaloons. Coming

in and out of existence through floods
of icy fog, they regard me, holding
their muslin canopies over my head,
reciting prayers of blindness.

In my vertigo, I posit these angels now,
not as beings, but as fictions of time
creating the framework of a necessary place.

A christ with white eyes
just touched my lips, blessing
by his cold, boneless fingers,
my faltering way.

II
These Know Nothing of the Word Winter

They can never speak of winds blowing
down from the Arctic, or wooly frost
in the nostrils of steamy ponies, or a dark,
early dusk descending, ominous as a lone crow,
into the stark branches of a sycamore.

Yet they are the very ones who draw their stems
slowly and beautifully into the collapsing
white umbrellas of themselves, who change
their multiple sun-faces easily to icy porcelain,
who fold the frozen rivers of their hands calmly,
as if they possessed a prayer.

They know so well how to become
all the powers of their own annihilation.

Tell us your names. Teach us your talents.

III

Spring Messianic in a Winter Storm

Beyond the rims and crevices
and stopped ledges of frigid
rock, beyond boles and black
burrows closed and corked
by snows and zeros, past omens
of gray sedges pressed beneath
battering dusts of ice—what was it
I saw in that distance, barely there
against the high, vast bleakages
of weather, a mere suggestion
of vision fluctuating before
the falling over, the white loss
of the plains?

What was it? nothing the eye
could truly catch—one blue leap
of match in the icy wind, one faltering
crimson flume of spark under snow,
a false igniting, a mis-struck
flare, a rip of hurried flag,
a failed signal.

Only much later in my sleep,
does the sound of it finally arrive,
coming as a brief turn of stringed
waltz in a smattering of unstrung
chords, a partial measure of polka
plunked on an ancient Pianola, one simmer
of jazzy cymbal, one redhot blare
of brass wavering offkey, fading,
snuffed out, vanished, as missing
from midnight as the dawn.

Winter Triptych, 1993, 31 × 45 inches. Courtesy Robischon Gallery, Denver

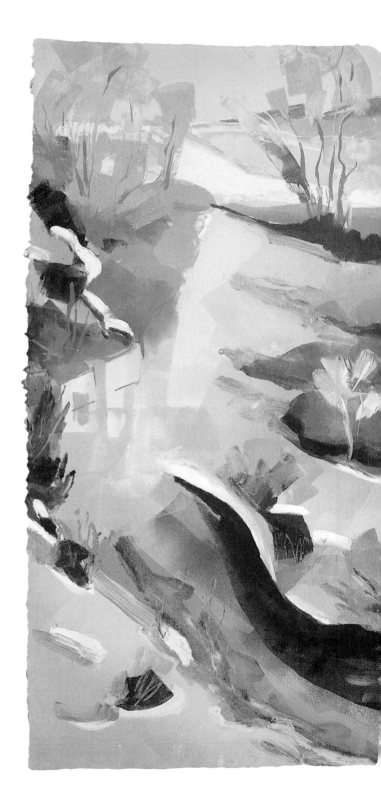

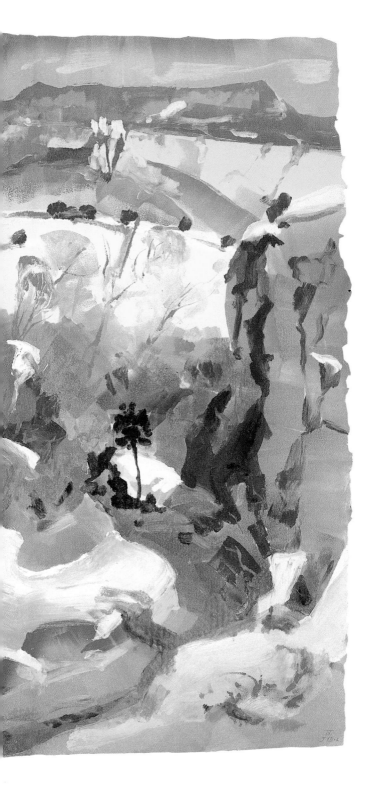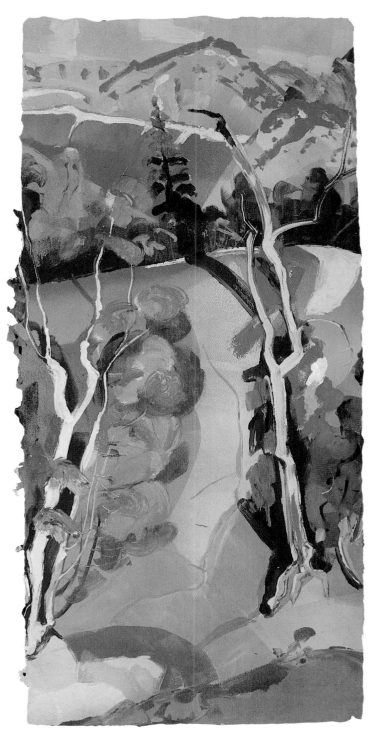

PORTALS TO GARDENS OF THE MIND

PORTALS TO GARDENS OF THE MIND

David Park Curry

"In the end, nothing is as beautiful as involuntary resemblance."[1]

—PAUL ELUARD

Making works of art—in paint, in wood or metal or stone, with words, with sound, with living plants—is largely a process of making choices, of distilling what is *wanted* out of all that there *is*. Even the most numerically determined system for the creation of abstract imagery is subject to the artist's arbitrary intervention to achieve aesthetic ends.[2] Aesthetic operation—choosing—continues, no matter what the style or medium or period of the artwork in question, no matter the cultural weight of tradition versus innovation under which the artist labors.

Conceived in a cultural matrix from which no artist can entirely escape, every work of art marks time to some degree. But each artwork also shapes time into tangible images or sounds whose evocative power may transcend the original context. An artist's choices are inevitably personal, and sometimes they have larger implications. In bringing together a selection of poems and paintings in this volume, *A Covenant of Seasons,* we have chosen, quite literally, to convene two contemporary artists, painter Joellyn Duesberry and poet Pattiann Rogers.

Before the project began, neither was aware of the other's work.

A covenant can be a contract, a binding agreement, a compact. It also holds out promise.[3] Our mixture of independent artistic expressions—word and image—is linked to the cycle of the seasons, with its double-edged promise of loss and renewal. While the seasons are not the primary focus of their work, both poet and painter touch upon an ancient theme that has engaged artists over the centuries from many cultures. Although neither artist has self-consciously set out to depict the seasons, the shape of time past and passing underlies the work of each.[4] Duesberry uses her art to tap the rhythms of the world around her. "It is rare to find a realistic landscape painter to whom nature seems so eager to speak," avers one critic. She "paints seasons without becoming sentimental and solitude without becoming either mystical or morbid," says another.[5] Rogers delights in making her points by speaking *of* nature, reveling in the language of the botanist, the geologist. She said in a recent interview:

A massive vocabulary... has come through scientific research and study...; scientists are imaginative about the words they give things, names like quarks and charm and

subatomic particles, the names of constellations and processes. It's just a very wide range of vocabulary that isn't only words and names, but it's when you get them all together you begin to realize what a world we live in, how massive and full of infinite variety and detail; the study of one snail can occupy a lifetime.... I think that's all affirming and sustaining.[6]

In "Reiteration" she writes:

The bonds of this contract are plural
and solitary, present in coon paw
and river print, in swallow and scat,
in rain falling on dry leaves,
like time in meter, chord
to arpeggio to chord.[7]

Arguing for the importance of art in daily life, novelist Jeanette Winterson remarks, "What is certain is that pictures and poetry and music are not only marks in time but marks through time, of their own time and ours, not antique or historical, but living as they ever did, exuberantly, untired."[8] It is our hope that this covenant of seasons will affirm and sustain the reader, resonating not only with the present, but also with the arts of previous times and places.

Landscape painting can hardly avoid seasonal elements, although the most interesting examples may not focus upon seasonal change for its own sake. American genre painter George Henry Durrie's *Winter in the Country: A Cold Morning* (Figure 1) combines a luminous,

highly finished winter scene with an evocative title. His carefully constructed visual experience invites the viewer in out of the cold, sending a clear message of shelter and hospitality linked to old-fashioned country ways. Under a frosted pearly sky, two travelers abandon the chilly discomforts of their red and green horse-drawn sleds pulled up under the welcoming red signboard of a rural tavern. The tavern's sunny yellow walls stand out warmly against the snow-filled yard. Durrie's bright colors set against the cool silvery background ensure that the viewer's eye goes directly to the inn's front door. The artist reinforced this movement by setting another traveler in the midst of a broad, sweeping path. He approaches on foot, carrying a basket and followed by a little dog. Nearby, farm hands are feeding animals, while a woman in country dress draws water from the well. The kettle, we may safely assume, will soon be on the boil.

It is no accident that Durrie's image, which reaffirms basic cultural values of shelter and sustenance, achieved widespread popularity at a time when the United States was torn by civil strife and coping with the challenge of a rapidly industrializing urban economy.[9] Durrie's concentration on people and rural buildings as gathering places for communal activities ensures that such pictures retain their accessibility over time as archetypal American statements of rural contentment.

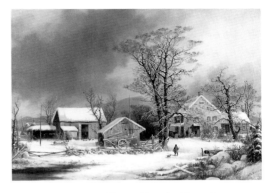

Figure 1 George Henry Durrie (American, 1820–1863), *Winter in the Country: A Cold Morning*, 1861, oil on canvas. Virginia Museum of Fine Arts; Purchase, The J. Harwood and Louise B. Cochrane Fund for American Art, 1992.

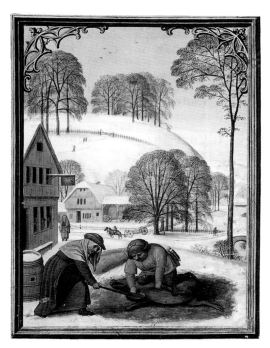

Figure 2 Simon Bening (Flemish, 1483/84–1561), *December,* from *Da Costa Hours,* ca. 1515, illuminated manuscript. The Pierpont Morgan Library, New York.

The roots of such pictures strike deeply into the rich soil of much earlier European art—the first books of hours decorated with the labors of the months and the more ambitious cycles of seasonal paintings that followed. For three centuries (1250–1550) books of hours were the dominant choice of the reading public. These medieval "bestsellers," produced in greater numbers than any other type of book, including the Bible, marked time with their series of prayers and illuminated calendars. But they also shaped time, encouraging meditation that transported the user from the distracting cares of this world to the divine pleasures of the next.[10] Their highly decorated pages offered the opportunity for some of the earliest landscape paintings. Inspired by the *Très Riches Heures* of Jean, duc de Berry, the Flemish illuminator Simon Bening used a traditional subject of a calendar miniature—the butchering of a hog during the month of December—for a full-page presentation of a wintry landscape (Figure 2).

In a series of six canvases painted in 1565 and perhaps used as a decorative scheme at the house of Niclaes Jonghelinck in Antwerp, Pieter Bruegel the Elder went beyond the labors of the months to explore nature's cyclical changes.[11] Although he provided topographically convincing locales for his pictures, Bruegel was less interested in a specific place than in a general impression of characteristic seasonal atmosphere. While today one thinks almost automatically of the four seasons, Bruegel provided six images in his cycle.[12] These are the ancestors of works by contemporary artists dealing with seasonal themes. Indeed, now-iconic images such as Bruegel's *Hunters in the Snow* (Figure 3) are often cited by contemporary artists as their inspirations.[13]

Like the fecund seeds in one of Pattiann Rogers's poems, the ideas and ideals contained in early European seasonal imagery have generated an endless flowering of subsequent artworks, not to mention objects from popular culture—from nineteenth-century gift books and chromolithographs to twentieth-century gas station calendars, cocktail napkins, and greeting cards. In a lyrical examination of landscape and memory, Simon Schama notes:

The designation of the suburban yard as a cure for the afflictions of city life marks the greensward as a remnant of an old pastoral dream, even though its goatherds and threshers have been replaced by tanks of pesticide and industrial-strength mowing machines. And it is just because ancient places are constantly being given the top-dressings of modernity (the forest primeval, for example, turning into the "wilderness park") that the antiquity of the myths at their core is sometimes hard to make out.[14]

Contemporary urbanites are considerably closer to ancient ways than they may realize. A gardening manual or a cookbook can be structured around seasonal changes that once played a far greater role in daily life than they do now. A personal reminiscence can gain delicate and subtle

tone through a seasonal theme.[15] All of these—high art and low—let us condense time and operate simultaneously in past, present, and future, offering a legacy of preternatural comfort couched in aesthetic pleasure and reinforced by readily available commercialized images.[16]

Slightly earlier than Durrie's painting, Franz Schubert's *Winterreise* was written in 1827, the year before the composer's death. Schubert offers a darkly compelling cycle of twenty-four *lieder* that carry the listener back and forth in time from present to both past and future. Schubert set the words, by poet Wilhelm Muller, within a concise musical framework, exercising his prolific imagination to express every shade of poetic meaning. The listener is literally grounded in a deserted frozen forest where a man wanders after having been rejected by his beloved. Schubert's music charts an impermanent emotional landscape where life's fragility is marked by moments of evanescent beauty.[17] Not only the structure of the music itself, with insistent notes and shifts from major to minor key, but also the lyrics—of isolation, memory, despair, and resignation—carry the meaning. Schubert's subtle sense of rhythm lets him render the most delicate inflections and accents of the German language through his music. Although the entire series is set in a wintry wood, the traveler finds himself dreaming of spring. In the eleventh song, he wakes in a forest hut to see flowerlike frost patterns on the windows—

"When will you leaves grow green on the window?" he wonders:

> I dreamed of gay flowers
> such as blossom in May;
> I dreamed of green meadows,
> and the merry calling of birds.
> And when the cocks crowed,
> my eyes awoke;
> it was cold and dark;
> the ravens were croaking on the roof.
> But there on the windowpanes
> who had been painting leaves?
> You may well laugh at the dreamer
> who saw flowers in the winter.[18]

At the end of the cycle, the wanderer encounters an inn—but unlike the welcoming inn of Durrie's painting, Schubert's inn is actually a graveyard, and instead of shelter the wanderer finds only madness.

Why laugh at one who sees spring flowers in dreams? Although not burdened by the baggage of romantic angst, Duesberry and Rogers also move through seasons, taking us back and forth in time. Duesberry regularly seeks locations where the seasons seem ambiguous or atypical—winter in New Mexico, summer in Alaska, fall in California, spring in Colorado. Subtle transitions interest her more than a full-blown seasonal peak, for, like Schubert's wanderer dreaming of spring in the midst of winter, Duesberry sets up tensions in her work—offering us, say, a summer forest in Maine, as in *Pretty Marsh Triptych II* (page 49), rendered in an acid palette with the implication that winter's chill is not far behind. In others of her works, such as *Chama Triptych*

Figure 3 **Pieter Bruegel the Elder (Netherlandish, 1525/30–1569),** *Hunters in the Snow,* **1565, oil on canvas. Kunsthistorisches Museum, Vienna.**

Figure 4 Detail from wallpaper depicting the four seasons, British, 1768, tempera on paper, after Nicolas Lancret (French, 1690–1743). Entry hall from the Van Rensselaer house, Albany, New York. Metropolitan Museum of Art, New York; wallpaper gift of Dr. Howard Van Rensselaer, 1928.

(page 81), the landscape changes so little from one season to the next that only the quality of light signals the season. Rogers allows seasonal images to come and go in no particular order. They combine to become another reality. She notes: " In our memories, there is no order to seasonal images. And considering the earth as a whole, which is something I like to do, all seasons are present at every moment— winter coming and going in the Northern Hemisphere as summer is coming and going in the Southern, and vice versa."[19] In the final section of "Winter Matches" (page 123), the sound that finally reaches the speaker's ears is the sound of life not yet realized in the winter landscape but anticipating itself. Spring and summer images are present within our experience of winter. In Rogers's poetry, the bones of winter are acknowledged in the body of summer, just as the bones of landscape are revealed in Duesberry's abstracted images of mountains, meadows, and plains.

Removal and distance are key aspects of artistic resonance. The Van Rensselaer mansion was built in Albany in 1765–69. Its principal public space, one of America's largest surviving pre-Revolutionary interiors, boasted hand-painted English wallpaper embellished with the four seasons— watering a garden in spring, picking grapes in summer, scything grain in autumn, skating in winter. This entry hall is now displayed as a period room at the Metropolitan Museum of Art in New York (Figure 4). Based on engravings of paintings by French rococo artist Nicolas

Lancret (1690–1743), the images are set against a light-hearted yellow background.[20] Rendered *en grisaille*—as silvery gray as a low-toned winter sky—the imagery is several times removed from its original inspiration (from French painting via engraving to English wallpaper manufactory to American setting). These scenes nonetheless must have provided aesthetic pleasure and reassurance during a frigid winter in colonial New York.

My own earliest seasonal reassurance, as a child growing up in North Dakota, was far less exalted. In January I would turn the pages of the latest Standard Oil calendar forward to March or April. When those months finally rolled around, the snow drifts outside my window seldom matched the lithographed picture of a jolly suburbanite planting his garden, but such illustrations function just like precious colonial wallpaper, or Duesberry's shimmering colors or Rogers's elegant phrases, serving as portals to gardens of the mind.[21]

In his recent study on the languages of landscape, Mark Roskill suggests that compression and distillation are used by artists over time and across different cultures as tools to set up resonances in the minds of viewers:

Compression and distillation entail singling out from a vast expanse or range of possibilities in nature those elements that effectively bring into focus key aspects of experience. Resonance causes the viewer to search in the memory, through the personally charged

associations and paths of recollection that are evocatively set up.[22]

Works by Duesberry and Rogers share a reliance upon the evocative use of compression and distillation. Duesberry's ultimate source of inspiration is the landscape itself, of course, while Rogers embraces not only the natural world but also the printed word—anything from a scientific tome to a newspaper report. While both painter and poet have long been concerned with landscape, Duesberry's monotypes and Rogers's poems are complementary voices, functioning independently. And our own responses as viewers or readers of their art can be quite personal, resonating with our own memories and associations.

The process of monotype distances Duesberry from the potentially overwhelming detail of the countryside she paints, pushing her toward abstraction.[23] Like Alice stepping through the looking glass, Duesberry encounters a new world through monotype, a process that reverses, flattens, blends, and bleeds the image brushed on the plate. Her distillation of plein air paintings down to a minimized economy of plane, line, or gestural brush track is at least twice removed from the natural forms that first provoked the work. One need only compare an early oil, *Buffalo Pass* (Figure 5), with a later monotype of the same subject (page 92) to understand how far the printing process has taken her. With their luscious, sensuous surfaces, these monotypes feed the eye. Reviewing one of her recent exhibi-

tions, a journalist bravely commented, "There is still a need for plain old beauty in art, whether or not it has an edge or whiff of danger to it."[24]

Using her finely tuned linguistic sensitivity to evoke an idea with a few well-chosen words rather than a prolix description, Rogers creates spare stanzas that not only mark out her own territory within the spiritual and physical forces that govern our lives, but also brush with ageless beauty. As critic Leslie Ullman recently commented, "Reading them, one may be reminded of the original functions of poems—to restore, to provide sustenance, to sing rather than preach faith—and may be reminded also of the revered bards and sages who sang them."[25]

When Oscar Wilde wrote *The Picture of Dorian Gray* to explore a Faustian bargain with physical beauty—an unquantifiable element that was dangerous for the Victorians—he used a fictive portrait to distance himself from issues of sin and the desire for beauty that does not age. "Nothing but the senses can heal the soul," Wilde opined.[26] A century later Rogers created a fictive turn-of-the-century love letter to distance her own voice from the sensuous present in "The Possible Salvation of Continuous Motion":

> *If the horses could go fast enough across*
> *the ice*
> *So that no one would ever be able to say,*
> *"Sin*
> *Was committed here," our sin being as*
> *diffuse*

Figure 5 Joellyn T. Duesberry, *Buffalo Pass*, 1991, oil on panel. Private collection.

As broken bells sounding in molecules of
 ringing
Clear across the countryside;

And under the blanket beside you in the
 sleigh
If I could watch the night above the flying
 heads
Of the horses, if I could see our love exploded
Like stars cast in a black sky over the glassy
 plains
So that nothing, not even the mind of an
 angel,
Could ever reassemble that deed;

Well, I would go with you right now. . . . [27]

In her exploration of "possible salvation," Rogers creates her own personal, brand-new myth. But Simon Schama wonders if we have left some of the old ones too far behind. As we try to cope with an aging ecosystem, Schama asks whether

a new set of myths are what the doctor should order as a cure for our ills. What about the old ones? . . . our entire landscape tradition is the product of shared culture, it is by the same token a tradition built from a rich deposit of myths, memories, and obsessions. The cults which we are told to seek in other native cultures—of the primitive forest, of the river of life, of the sacred mountain—are in fact alive and well and all about us if only we know where to look for them.[28]

Schama suggests that we look for the strength of links that bind Western culture and nature by digging beneath layers of

the commonplace. So does Joellyn Duesberry with her long career insisting on the validity of traditional landscape painting. And so does Pattiann Rogers.

Whoever said the ordinary, the mundane, the commonplace? *Show them to me*

demands the poet in "Till My Teeth Rattle." She continues:

There's no remedy, I suppose—this body
just made from the beginning to be shocked,
constantly surprised, perpetually stunned,
poked and prodded, shaken awake,
shaken again and again roughly, rudely,
then left, even more bewildered,
even more amazed.[29]

Of course, the physical body endures many a shock on its inevitable path from cradle to grave, and it is hardly surprising that seasonal imagery is directly linked to another ancient theme, the four ages of man (childhood, youth, adulthood, old age). Addressed in an allegorical manner with plenty of togas, classicizing architecture, and telling natural details such as sprightly spring flowers or thundering cataracts edged by lightning-blasted trees—such a topic remains at a comfortable remove. Thomas Cole's *Voyage of Life* made an excellent subject for inspirational sermons as well as uplifting steel-engraved reproductions intended for the parlor.[30] A critic for the *New-York Mirror* bubbled in 1841:

This series of pictures has just received the last touches from the artist, and it must be a matter of felicitation to all, that these

master-pieces of art are now open to public inspection. In this work there is an instance of the art being devoted to its highest objects—to the illustration of the moral truths of nature—to the cultivation of refined sentiments—to the improvement of the heart. It holds life before us, as it were, in a mirror; it shows us at a glance the hopes and vicissitudes of this checkered existence to the verge of termination, and then gradually leads us to the contemplation of glorious futurity. It is a moral poem, conveyed to us in the "universal language" of the painter's art, and leaves no regret that the "pictorial poet" is deprived of the advantages of continuous description in the treatment of his subject. The allegory is complete; the joys, hopes, fears of life are all portrayed (part, alas! in its true colors).[31]

"Youth," of course, was considerably more popular than "old age." The young man setting out on the river of life (Figure 6) reappears in countless replications ranging from oil paintings to needlework pictures.

But what happens when an artist explores the link between seasonal change and life's ineluctable course on too personal a level, or reveals too much about changing social patterns, thus raising the viewer's discomfort level? In *October*, James Tissot's mistress strikes an arresting pose for a "specimen" portrait (Figure 7). But the portrait's fashionably allegorical overtones failed to mask too close an association between artist and model from the conservative and jingoistic London art world. The Frenchman's liaison—a "curi-

ous menage of a fashionable painter with a mistress and a ready-made nursery of illegitimate children"—hardly went unnoticed. Indeed, taken to task for his lack of "aesthetic respectability," Tissot eventually left London for Paris.[32]

Like Cole's lad in *The Voyage of Life: Youth*, Kathleen Newton is youthful. She peeks over her shoulder with a coy come-hither look. But our own backward glance at history tells us that Tissot's great love and favorite model was terminally ill with consumption and would die within a few years. In his essay "The Earthly Paradise," Michael Wentworth discusses Tissot's images of Newton as a "stylish cypher," who appears "as generalized as the heroine of any penny romance."[33]

Tissot constructed his image incorporating not only the kind of sinuous, fluid pose and highly decorative surface so often encountered in Japanese ukiyo-e woodblock prints, but also in then-contemporary developments in the decorative arts, particularly Victorian wallpapers that quoted a dramatically stylized nature. Owen Jones, for instance, had introduced a chestnut-leaf pattern quite like Tissot's bower as early as 1856 (Figure 8). Despite these references to other arts, Mrs. Newton occupies so specific a present that her universality is somewhat compromised. Created only a few years before Tissot painted *October*, a set of equally stylized, equally fashionable French marble figures of the four seasons, including *Pomona* with her generic basket of spring flowers (Figure 9), retains a chill, stony distance.[34]

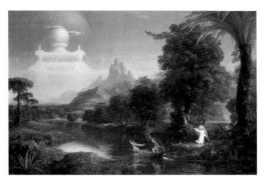

Figure 6 Thomas Cole (American, 1801–1848), *The Voyage of Life: Youth*, 1842, oil on canvas. National Gallery of Art, Washington, D.C.; Ailsa Mellon Bruce Fund.

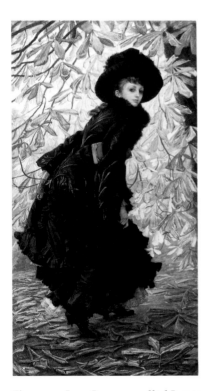

Figure 7 Jean-Jacques, called James, Tissot (French, 1836–1902), *October*, 1877, oil on canvas. The Montreal Museum of Fine Arts; Gift of Lord Strathcona and family.

Figure 8 Owen Jones (British, 1809–1874), *Leaves from Nature No. I*, plate XCI in *The Grammar of Ornament* (1856; London: Bernard Quaritch, 1868).

Figure 9 *Pomona*, French, mid–19th century, marble, after a sculpture by François Barois (French, active late 17th century), ca. 1686–96, following designs by François Girardon (French, 1628–1715). Private collection.

But Newton, too, transcends time in this over-life-size image with its portal-like vertical format. On one level, her black hat and day dress, once the *dernier cri,* now render her quaint. Her brightly enameled expression is as endearing as that of an expensive Madame Alexander costume doll. On another level, almost obscured by ruffled black silk, the figure resembles the trunk of a twisted tree whose leaves drop past the rough bark in the crystalline autumn air. In "Janus" (page 107), Pattiann Rogers writes of "the body we know: / the one prolific with seeds." Her words let us detect in Tissot's *October* "the rock-permanent light of the heart born in every seed rising to death."

I wish I could step through a portal back into a time when the anxiety of influence was unknown. Despite the endless turning of fashion's wheel (platform shoes are back again), despite movements in the arts that regularly echo and derive from previous movements (Art Nouveau's debt to the Rococo; postmodern architecture's link to Victorian eclecticism), I cannot help wondering whether, as the twentieth century draws to a close, the Shock of the New has caused a bewildering Fear of the Familiar. Whether they let on or not, both traditionalist and avant-garde artists usu-ally understand that a part of their task is to carry on some sort of dialogue with the arts of the past.[35] But journalists of our own era are quick to pick up and report to the general public how a contemporary artist, burdened with the post-Romantic myth of genius, might be "intimidated by the great achievements of the past."[36] Mistrusted as elusive concepts of beauty, formalism, and taste remain in a contemporary art market largely driven by political agendas, it is easy to overlook continuities and resonances in the arts that resound across time and cultures.[37]

David Shapiro notes, "Too often poetry is compared to painting only in its descriptive function." Of course the relationship is far more complex. Shapiro cites the linguistic studies of Roman Jakobson, who explores how grammar is comparable to geometry. As the poet must acknowledge the rule systems of grammar, choosing whether or not to ignore them, so the artist contends with the forces of geometry.[38] "A poem is a form," Pattiann Rogers observes, and she loves "to write so that I [say] a lot in a few words, which is one of the aims of poetry."[39] Joellyn Duesberry has to work fast to lay her inks down and print a monotype image on paper before the inks dry. Whereas the hundreds of shades and tones that appear in her oil paintings are created from seventy-six available oil colors, the myriad equally nuanced shades in her monotypes are constructed from a simplified palette of only eight oil-based lithographer's inks. Duesberry has learned to choose her movements carefully, get-

ting down to the most important structural elements in her pictures. Using ever larger brushes, she edits the structure down to its most vigorous essence.

The painter's need "to fall back on raw energy and wide brushes to respond to quirky shapes and absolute light and dark"[40] is evident in her *Winter Triptych* (pages 124–25). The piece is based on three different pictures, executed in a series as December turned to January in the Rocky Mountains. While chasing the winter down toward the arid San Juan Valley, the artist absorbed the idea of cold—brilliantly illuminated by raking winter sun. The monotypes are printed on a rough paper made from potatoes with tiny mica chips mixed in; these earthy ingredients seem to incorporate winter's chill. The rich rusty reds splashed over the surface do not penetrate the paper, but like winter sun on frozen ground, they radiate unexpected warmth. Maybe nature is sleeping, yet winter is anything but monochromatic, bleak, uniform.

Winter Triptych is one of four sets of monotypes by Duesberry that have been incorporated into screens, further widening the net in which multiple meanings can be caught. Like screens, paintings and poetry divide space. Noting that a Chinese poet may have made the first screen, David Shapiro comments that "the screen in art and literature is a constant" and sees both painting and poetry as "screens against chaos: curtains, shadow plays for Prufrockian nerves."[41]

Perhaps the "Prufrockian nerves" of the expatriate business community in Tokyo were soothed recently by a full-color photograph of autumnal flowers that occupied one quarter of the front page of *The Japan Times* (Figure 10). There is no related story, only a caption that reads, "Cosmos flowers are in full bloom in an uncultivated rice field as autumn arrives in Asuka, once the flourishing home of an ancient Japanese culture." Various flowers and trees are well known to the Japanese as seasonal markers, for in old Edo (now Tokyo), the rhythms of city life were closely tied to variations in the seasons, whose observance and celebration were well established by the seventeenth century.[42]

This aspect of Japanese daily life survives not only on the front pages of no-nonsense business periodicals, but also in many a Japanese screen embellished with seasonal motifs. The most straightforward examples simply inventory typical vegetation, taking the viewer on a journey through time. A pair of six-panel screens by an unknown Tosa School artist, *Trees and Plants of the Four Seasons* (ca. 1500; Idemitsu Museum of Arts, Tokyo), offers, from right to left, a succession of blossoming red plum, bamboo grass, spearflowers, lilies, hydrangeas, bellflowers, patrinia, bush clover, pampas grass, and scarlet maple leaves. In the upper left of the second screen, distant pines on snow-capped mountains signal that the progression of the seasons is complete. Scattered over the surface, a shimmering layer of mica and

Figure 10 *The Japan Times*, front page, 1 October 1997.

fine particles of silver, now unfortunately oxidized to black, would once have glittered, giving the mesmerizing effect of rising mist caught in the sunlight.[43]

Other Japanese artists present their message less literally. Ike Taga varied his brushwork to emphasize the gradual flow of the seasons in his pair of six-panel screens *Landscapes of the Twelve Months* (late eighteenth century; Idemitsu Museum of Arts, Tokyo).[44] Soft, wet brushstrokes and delicate washes appear in the summer scenes, but in the winter panels he relies on articulated brushstrokes that are stiffer and more angular, conjuring up raw winter weather. Similarly, in Duesberry's monotypes the soft passages of summer made with wet brushes, as in *Mount Desert from Calf Island* (pages 54–55), give way to staccato forms of winter, created with hard-edged rubber rollers in *Pedernal and Snowfields III* (page 109). And Rogers sometimes governs her vocabulary in the same way, using soft sounds to conjure warm weather in "Rolling Naked in the Morning Dew" (pages 50–51):

> . . . *the single petal*
> *Of her white skin could absorb and assume*
> *That radiating purity of liquid and light*

but exchanging these for harder sounds in "Winter Matches" (pages 122–23), where she wants to evoke the cold:

> . . . *one faltering*
> *crimson flume of spark under snow,*
> *a false igniting, a mis-struck*
> *flare* . . .

Rogers's poems sometimes straddle seasons. In "Winter Fishing" (page 113), the speaker, caught on the winter side of the ice, watches the commotion and activity of spring and summer through "the cold, cold glass." And Duesberry's winter screen, with its edgy red palette, does not immediately reveal what season we are actually in.

Similarly, Ogata Korin's golden screens depicting irises and a zigzag wooden bridge (Figure 11) are not primarily concerned with seasonal change. His central theme is poignant loneliness caused by absence. The screens are a bold abstraction of a well-known episode from the tenth-century *Ise Monogatari* (Tales of Ise), a series of poems about love and journeying. Happening upon the Eight Bridges (*Yatsuhashi* in Mikawa province), the hero, Narihira, is moved by the lovely iris growing in the marsh. Commemorating this poignant moment, the young Heian-period aristocrat composes the following poem:

> *I have a beloved wife,*
> *Familiar as the skirt of a well-worn robe,*
> *And so this distant journeying*
> *Fills my heart with grief.*[45]

For a Japanese viewer, the profusion of luscious iris blossoms would signal early summer, giving the viewer a sense of time as well as of place.

An unexpected kinship with this ancient Japanese tale can be found in Rogers's evocative conclusion to a poem that begins, "Compassion, if it could be

seen, might look / like an early blossom of iris":

> *. . . maybe the benevolence inherent to*
> *ordinary*
> *Purple-streaked flowers could be understood*
> *As they cover, without intrusion, the lowest*
> *rim*
> *Of evening, when they draw their violet lines*
> *As carefully as dusk draws time above the*
> *dusty floor*
> *Of the pine barrens. Corms and stems,*
> *Lobes and basal clusters might be*
> *Recognized as the subtlest, most crucial*
> *Tenderness of the soil.*[46]

In the early evening—*"l'heure bleu"*—the Colorado light briefly turns an almost electric blue while the Rocky Mountains that form a distant background for Duesberry's Denver flower garden sink to a dusky purple. A single stroke of low-toned periwinkle pigment in one of her paintings or monotypes, as in *Garden on a Cloudy Day IV* (page 47), can transport me there.[47]

Looking for links between poetry and painting, David Shapiro notes:

Perhaps the central cross for poetry to bear . . . is the distance between signifier and signified. That is, any word bears only a differential meaning in its language and does not have absolute designating status. It may be that a word in this sense refers to an object only in the indirect way that a form in a painting refers to an object: by arbitrary convention.[48]

Surely, the less recognizable the subject matter, the more a painter suffers that same problem when presenting the work to bemused viewers. Unfortunately, the opposite side of the equation can be just as limiting. In a world driven by fashion, familiarity can breed contempt. Charles Burchfield complained, "I feel that my best, most original work is in the field of nature, the change of seasons, and weather; yet the art world generally does not recognize this."[49]

Even an old chestnut may be worthy of scrutiny. As early as 1740 a music critic asked, "Who does not know the Four Seasons of Vivaldi?" When Antonio Vivaldi (1678–1741) published his Opus 8, *Il cimento dell'armonia e dell'invenzione* (The Contest between Harmony and Invention, ca. 1725), he stretched the concept of "program music" while breaking new ground

Figure 11 Ogata Korin (Japanese, 1658–1716), *Irises and Bridge* (detail), ca. 1711, pair of sixfold screens, ink and color on gilded paper. Metropolitan Museum of Art, New York.

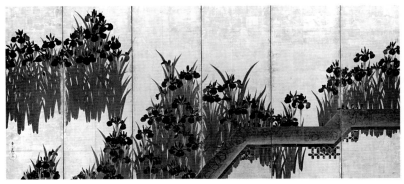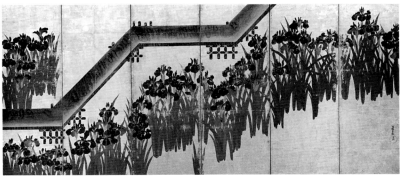

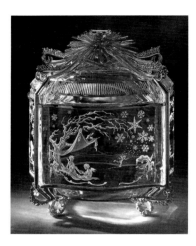

Figure 12 Four Seasons coffret, Steuben Glass, 1969, glass, green gold, and sapphire, with engraved images designed by Alexander Seidel. Virginia Museum of Fine Arts; Gift of Mr. and Mrs. Donald Pollard, 1989.

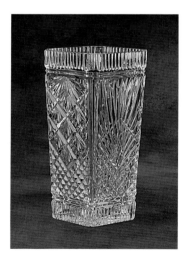

Figure 13 Four Seasons vase, Designer's Gallery Collection, Waterford®, 1994, glass, designed by John Whelan. (Waterford® and the Seahorse design are registered trademarks of Waterford Wedgwood Plc, Kilbarry, Waterford, Ireland.)

by exploring the Baroque solo concerto's possibilities (Vivaldi was himself a noted violinist, among other things).[50]

The first four of these twelve concertos are collectively known as *Le quattro stagioni*. They remain Vivaldi's most popular works, although there was quite a stretch of obscurity between the composer's death and a revival of his work during the 1930s. Are these concertos just a musical cliché?[51] Do we really agree that early program music like Vivaldi's was "childlike in its attempt at pictorial representation" and "happy to take its cues from the most immediate associations of the audible: tumult of battle, bird-song, peal of bells, or thunderstorm and pastoral sounds?"[52] In listening to this sprightly music, how easy is it to differentiate "the lovely murmur of leaf and plant" *(Spring)* from "the mild air that gives pleasure" *(Fall)* without the sonnets that Vivaldi wrote to clarify his intentions for his patron? Without lyrics, program music remains somewhat inaccessible—not unlike "wit" in postmodern architecture when encountered by the uninformed. Vivaldi's sonnets open up our range of reactions to his music. For example, in *Summer,*

> *Weary limbs are robbed of their rest*
> *by fear of lightning, and fierce thunderclaps,*
> *and of the wild swarming of midges and flies.*
> *Ah, sad to say, [the shepherd's] fears are well*
> *founded,*
> *the heavens thunder and flash, and hail*
> *lays low the ears of grain and the proud*
> *wheat.*[53]

Few actually read these sonnets today, if they are even aware that Vivaldi wrote them for his patron, Count Morzin. As jacket copy on a current CD notes, the count, "who lived in a castle in the Bohemian mountains, finally understood what was new: Vivaldi had 'painted' trilling birds, murmuring streams, gentle winds, mighty storms, barking dogs and dozing shepherds." The writer concludes that *Le quattro stagioni* are "the forerunners of film music."[54]

Like sequential images on a reel of celluloid, engraved motifs let the seasons unfold on the transparent side panels of a crystal, gold, and sapphire coffret made by Steuben Glass in 1969 (Figure 12). Cupids engage in seasonal activities, such as gardening, fishing, picking apples, and, shown here, skating. But words are as helpful to the modern consumer as they once were to Count Morzin when it comes to the abstract patterns embellishing Waterford's current "Four Seasons" crystal vase inspired by Vivaldi's music (Figure 13). Winter's stillness is "represented by the simplicity of long olive cuts—a stark contrast to the more complicated patterns on the other panels. Continuous bands cut around the top and bottom of the vase bind the four seasons together, serving as a reminder of the never-ending cycle of changing seasons," and so on.[55] Together, explication and resonance can enrich the exchange between one art form and another.

Few expressions of aesthetic criticism have led to more comment over a period

of several centuries than the Horatian simile *"ut pictura poesis"* (as is painting so is poetry).[56] Futurists, Dadaists, Surrealists, and members of de Stijl reaffirmed the relationship in the early decades of the twentieth century, and it appears again in the midcentury work of the concrete poets.[57] But one scholar warns:

Today, painters and poets seldom study the Horatian simile and the expanded "texts" of the Italian, French, and English treatises on the humanistic theory of painting, and few artists care whether painting ever had a superior, an elder, or any sister. Oriental theories of the blending, not to say confusion, of art forms are more likely to arouse interest in the kinship and rivalry of poetry and painting. If painting now seems too varied to allow anyone to define it precisely, the same is true of poetry.[58]

Whether one chooses to see poetry and painting as bickering siblings or passionate partners, as explored in the substantial literature over the centuries, in the end both artists and critics may be better off not thinking about influence, but exploring cultural conjunctions, such as we find in the monotypes of Joellyn Duesberry and the poems of Pattiann Rogers.[59]

It is easy to see how the maker of a landscape garden must needs edit the natural world for practical as well as pictorial or even poetic reasons. From the Renaissance garden at the Villa d'Este in Tivoli (1509–72) to William Shenstone's "smoothing . . . the robe of nature" at the Leasowes, his Georgian garden in Shropshire (1743 ff.),[61] to Ian Hamilton Finlay's careful shaping and textualizing of Little Sparta, a contemporary landscape garden in a remote part of the Scottish lowlands, gardeners intrigued by the intersection of the visual and the verbal have invited us to enter poetic mindscapes beyond the natural world. Historian Roy Strong comments, "In modern gardens a bench is a thing to be sat upon; in William Shenstone's garden it was a thing to be read." He describes Little Sparta as another garden of the mind:

Everywhere you look you are reminded of that fact, as you wend your way from shady grove to sparkling stream, from tranquil lake to dank grotto; and all punctuated by inscriptions hung from the branches of trees, broken classical capitals flung down upon the turf, or the sudden apparition . . . of a golden face peering upwards from the water's edge. No other garden has made me so aware of the poverty of context of nearly all late-twentieth-century gardens.[62]

Among the statuary decorating Finlay's garden are seemingly simple messages written in stone, such as "see Poussin, hear Lorrain." From the slender branch of a tree weighted with fruit, a stone tablet

II. Consoling Structures: Nature into Art

"To say to the artist that Nature can be taken as she is, is to say to the player that he may sit on the piano."[60]

—James McNeill Whistler

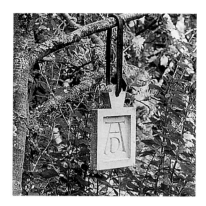

Figure 14 Sculpted medallion of Albrecht Dürer's monogram in Ian Hamilton Finlay's Scottish garden, Little Sparta. Photograph by Andrew Lawson, 1995.

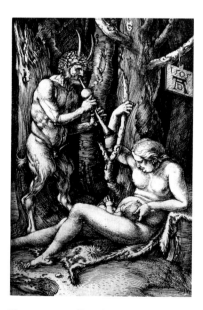

Figure 15 Albrecht Dürer (German, 1471–1528), *The Satyr's Family*, 1505, engraving. Metropolitan Museum of Art, New York; Mr. and Mrs. Isaac D. Fletcher Fund, 1919.

dangles; it bears Albrecht Dürer's monogram (Figure 14), establishing, as Strong puts it, "a dialogue across time to one of the great delineators of the natural world in Northern European art."[63] But the natural world, for Finlay as for Dürer (Figure 15), is still populated with gods and spirits.

The human desire to subject nature to an editing process seems less evident when we contemplate landscape painting—particularly if the artist's chosen topic is rendered in a naturalistic style that approximates human vision, as is the case with much nineteenth-century American art. Yet even the most veristic Hudson River School landscape—say, a convincingly evocative vision of autumn in New England by Jasper Francis Cropsey (Figure 16)—turns out to be a studio production, a composite made up of assorted views sketched on the spot. The artist wrote in 1847:

The axe of civilization is busy with our old forests, and artisan ingenuity is fast sweeping away the relics of our national infancy.... What were once the wild and picturesque haunts of the Red Man, and where the wild deer roamed in freedom, are becoming the abodes of commerce and the seats of manufactures.... Yankee enterprise has little sympathy with the picturesque, and it behooves our artists to rescue from its grasp the little that is left, before it is too late.[64]

Despite the influential exhortations of theorists such as John Ruskin, who advo-

cated the close scrutiny of the natural world and artistic adherence to nature's "truths," Cropsey knew better than to rely on outdoor sketching alone to capture the vision of nature he had in mind. As Whistler—Cropsey's contemporary and a pioneer in the gradual development of abstract painting—put it, "seldom does nature succeed in producing a picture."[65]

America's vast national parks were not simply celebrated, but in essence were generated by the colossal canvases of Thomas Moran, painted to convince a congress of unbelieving Easterners to protect a part of the national patrimony. A century later, as the nation's park system struggles to accommodate thousands of annual visitors—and the closure of the parks to individual vehicle traffic inexorably approaches—Moran's paintings still offer portals to the gardens of the mind.

Mark Roskill unearths multiple layers of significance for the seemingly simple term "landscape":

Landscape establishes a ground for the extended sharing of social attitudes and patterns of social behavior (as in tourism or the environmental protection movement). It represents continuously contested territory over which private and public interests meet or diverge, as to what is done to its appearance and with the aid of whom, and to whom it belongs in respect to both use and enjoyment. It constitutes a habitat in which the behavior patterns and rituals of the animal kingdom take their place as subjects of curiosity and vitalistic interrogation. It provides a setting for stories and staged performances (usually fantastic). Interests,

individual and communal, deriving from these considerations have gained purchase on the intellect and imagination from antiquity on, and since the Renaissance remain a constant in Western civilization.[66]

Perhaps we should not worry too much whether or not what we are shown in a picture or given to read in a poem was ever physically *there*. Every artwork can be partly understood as a performance on the part of the maker. Thomas Cole's *Falls of Kaaterskill* (Figure 17) coaxes the viewer to take a panoramic journey through the vast American wilderness. But in creating what is essentially a fantasy, Cole edited his actual experience of the site, aggrandizing the scale of the falls, while leaving out wooden walkways and viewing platforms built before 1825 for urbanized tourists wanting to glimpse the great American wilderness from a comfortable standpoint. Understanding what the artist puts in and what gets left out is a significant tool in interpreting a work of art in its historical context.[67]

It is impossible to separate nature from human perception. "Before it can ever be a repose for the senses, landscape is the work of the mind. Its scenery is built up as much from strata of memory as from layers of rock," Schama observes, going on to point out that

it is difficult to think of a single . . . natural system that has not, for better or worse, been substantially modified by human culture. Nor is this simply the work of the industrial centuries. It has been happening since the days of ancient Mesopotamia. It is coeval with writing, with the entirety of our social existence. And it is this irreversibly modified world, from the polar caps to the equatorial forests, that is all the nature we have.[68]

As they shape and modify the natural world in their pictures and poems, Duesberry and Rogers are among the artists who help us see the nature we have.

Duesberry's *Cattails in Winter III* (pages 102–3) silhouettes a few cattails—each black and brown fruit surrounded by a yellow halo of exploding seeds—against the goose-bump blue waters of a frozen pond. Brittle as jagged ice shards, the elements of the monotype retain sharp edges, for the artist has used a roller rather than a brush. The layered pigments with their sharp color contrasts allow the cattails to dominate the composition, dancing across the lower third of the image like a frieze above the dark curve of the near shore. Below the heavy but erect heads, wispy straws bend and droop. Distant trees are reflected in the sheet of ice, but the cattails are not.

In "Betrayal: The Reflection of the Cattail," Rogers sees:

The black lines of the cattail reeds sway in
 grace
Before the purple sky. On the stalk above the
 thick
Brown fruits of the velvet female, I can see
 the shriveled
Spike of the expended male making slow and
 crooked
Slices through the early stars.

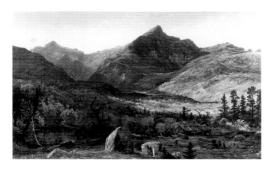

Figure 16 Jasper Francis Cropsey (American, 1823–1900), *Mt. Jefferson, Pinkham Notch, White Mountains,* 1857, oil on canvas. Virginia Museum of Fine Arts; Purchase, The J. Harwood and Louise B. Cochrane Fund for American Art, 1996.

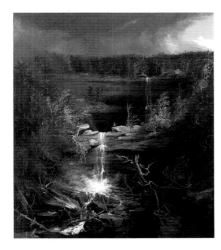

Figure 17 Thomas Cole (American, 1801–1848), *The Falls of Kaaterskill,* 1826, oil on canvas. The Warner Collection, Gulf States Paper Corporation, Tuscaloosa, Alabama.

She observes that:

*A single long leaf bends and bows above the
lake,
Its narrow tip barely tracing the surface of
the water
With the breeze. It moves, making random
trails exactly
Like an unfaithful lover makes, tracing with
her finger
The features of her only love.*

But:

*In the earth the cattail spreads
And widens its roots and the bases of its
reeds.
It presses down and holds on hard as if it
believed
The shore was its only faithful lover.*

For:

*The cattail knows how to bear the staunchest
grace
Beside the lake, just as if it didn't realize
It was being carried, along with us, across
the vast
Deceptive light of forgiveness this evening,
through darkness
Into darkness.*[69]

A hundred years ago John Muir may have likened Yosemite to an "artificial landscape garden . . . with charming groves and meadows and thickets of blooming bushes . . . as if into these mountain mansions Nature had taken pains to gather her choicest treasures to draw her lovers into close and confiding communion with her."[70] But, of course, it was he who edited and shaped raw matter into landscape—just as Duesberry and Rogers and the rest of us do now, whether on canvas, or on the printed page, or in the very ground itself.

We use our pictures and our poems the same way we use our gardens and national parks, to carry us along in an increasingly technological, urbanized, and commercialized society. The arts can work to restore the user. Making a psychoanalytic connection, Ella Freeman Sharpe wrote that art "is a bringing back of life, a reparation, an atonement, a nullification of anxiety. It is an omnipotent fantasy of control, of security from evil."[71] In applying Sharpe's thoughts to his study of Mozart, Maynard Solomon shows how the composer used the structure of his music—its symmetries, delicate balances, and ultimate closures—to maintain the fragile balance between ecstasy and trauma. "The composer has provided a consoling structure that does not accept loss or separation as a tragic finality," he writes.[72]

The individual elements pulled together in a landscape by Duesberry or a poem by Rogers let us link them again to earlier artworks that treat of the consoling cycle of seasons. Among the myriad treasures gathered up by J. Pierpont Morgan was a seventeenth-century nautilus goblet bearing motifs of the four seasons (Figure 18). Plucked from the natural world, the shell was engraved and transformed into a footed cup standing 17½ inches high, mounted in silver-gilt. The

"Schneckhen haus" (snail's house), as it is inscribed on the base, rests on the head of a tall, slender man, clad in a loincloth. He steadies the shell in both hands while standing on the back of a turtle who in turn rests on a base chased with acanthus leaves. Silver-gilt figures represent allegories of the seasons. Flanked by youthful figures representing Spring and Fall, Winter sits high atop the shell. A rather ancient and hoary old man placed front and center, he warms his hands over a fire in a brazier. His rich robes offer a stark contrast to the nearly naked bearer well below him.[73]

Bacchus embellishes the engraved whorl of the shell below the old man. The god of wine personifies Fall here, but lest his presence be misinterpreted, a text advises the user to heed the example of the snail and go slowly when it comes to drinking:

Se an das Schneckhen haus
Merck was es thue bedeüten
Fein langsamb trinck daraus
So haltst auf lange Zeiten.

[Look at the snail shell
And notice what it truly means
Drink slowly from it
You'll last longer that way.][74]

The elegant curves of a pond bank in Maine and a pale, shell-like form (in fact, an abandoned rowboat) are juxtaposed in one of Duesberry's monotypes, *Garden in a Dinghy I* (page 41). Like the carved ornamental tendrils that cascade down the back of the nautilus shell, bright nasturtiums tumble down the counterbalanced curves in Duesberry's composition. The inevitable loss of delicate flowers is not at issue here; the monotype keeps the festive red and yellow blossoms available for contemplation at any time of the year.

Sea nymphs and gods—Poseidon and Amphitrite, with their train of tritons and sea monsters—are also engraved on the nautilus shell. The shell of the rock barnacle in a poem by Rogers is not destined for silver-gilt mounts and elaborate chasing. In "What the Sea Means to a Rock Barnacle in a Tidal Pool," we learn that this humble shell

. . . will never recognize
the red clay bottom or the pelagic
deposits where his own abandoned
cement crust may one day descend
and descend to lie
at last in the general ooze.

But Rogers reassures us as well:

He can never understand its complete
essential being, clinging as he must
permanently to the shore rock
of these shallows.
.

But in the evenings, when he senses
the vast gold glowing of motion
extending itself before him, announcing
presence *so emphatically by its alteration*
of light, by his own anticipation,
and when that element rises, as it always
 does,
rushing, submerging, overwhelming him
 again
exactly like a great grief or a coming
exaltation, then I know he knows,

Figure 18 Standing cup, German, 1680, nautilus shell and silver-gilt mount. Wadsworth Atheneum, Hartford; Gift of J. Pierpont Morgan, 1917.

Figure 19 Attributed to the workshop of Bernard Palissy (French, ca. 1510–1590), platter, ca. 1565–70, glazed earthenware. Metropolitan Museum of Art, New York; Gift of Julia A. Berwind, 1953.

in the shudder of his own stalk,
something of the power, something
of the abundance, something of the forming
and failing explanation possessed
by that which he will never remember,
that which he cannot name.[75]

Neither the maker of the cup, nor of the monotype, nor of the poem has simply taken nature as found. Their involuntary resemblance allows us to speculate about underlying patterns of artistic form. Philosopher John Dewey discussed the "circular course of the seasons, . . . the ever-recurring cycles of growth from seed to . . . maturity, . . . the never ceasing round of births and deaths, . . . the rhythms of waking and sleeping, hungering and satiety, work and rest," concluding from such recurring natural phenomena that

Because rhythm is a universal scheme of existence, underlying all realization of order in change, it pervades all the arts. . . . Underneath the rhythm of every art and every work of art there lies, as a substratum in the depths of the subconsciousness, the basic pattern of the relations of the live creature to his environment.[76]

The colorful ceramics of Bernard Palissy and his followers replicate bits of the natural world—they teem with fish, frogs, snakes, shells, fresh ferns, and fallen leaves—into objects as small as a platter (Figure 19) or as large as a grotto interior. One of Rogers's poems, "Easter Frogs," could easily stand next to the platter shown here:

Like the reaffirming spring abundances
of violets, lilies, madders, starworts
and rosettes of sundew, frogs ascend anew
through anointing wet and warmth, mill
and move in the wash of light upon April
creekbeds and ponds.

Here comes one now. See first her bronze
iridescent eyes just resting on the water's
shimmering plain. She floats to full view,
click and glide. She's ripple flying,
wingborne, emerging now into the blackroot
rushes of the bank, a living body entire,
clearly rising up once again out of the dead
winter earth, reborn.[77]

At the same time Palissy was making his ceramics, Giuseppe Arcimboldo painted his capriccios, marvelous monsters representing the elements and the seasons, each face a clever orchestration of individual plant or animal forms (Figure 20). The original clients for such works of art included the royal courts of Marie de Medici and Rudolph II. If these objects seem bizarre or outlandish today, we can still appreciate the way the artists played with forms almost as a linguist manipulates words. Pallissy's ceramics offer a complete statement of a teeming forest floor or pond bank. Arcimboldo's paintings do not create signs, rather they combine and change them, exploiting the curiosities of language, making visual puns, playing with synonyms and homonyms.[78]

A careful assemblage of selected details pulled from the natural world makes up an image such as *Granite Quarry Triptych* (page 17). Duesberry gives us multiple textures—solid, striated granite boulders; puffy haloes of newly opened birch leaves; brackish backwater tinted by tannin from overarching evergreens; clear quarry waters so deep that reflections of blue sky glance off the surface, obscuring our reading of submerged rock shelves. Individual passages, some soft, others hard, some slick, some matte, cohere in the final, overall impression.

Meanwhile, again and again Rogers assembles her colorfully fecund vocabulary—words from "toad slush" to "cattywampus"—into moving visions of the sublime in nature. Although she delights in the "singular tastes and shapes of words," their individuality punctuates rather than overwhelms the whole.[79]

The monotypes of Joellyn Duesberry and the poems of Pattiann Rogers gently embrace the temporal in the face of the eternal. Modest details in the monotypes indicate man's presence in the landscape—a square magenta color note that turns out to be an abandoned truck bonnet in a dried-out arroyo (*Orchard and Arroyo II*, pages 78–79), the edge of a cottage roof almost hidden behind towering trees (*Striped Fields in Spring II*, pages 30–31), a grid of straight lines that offers a bridge over which we might negotiate a forbidding chasm (*Padre Jim's Bridge II*, page 21).

Our own losses are soothed when Rogers tells us, in "Poverty" (page 29),

> *. . . only*
> *multitudes of serenities lay*
> *in the snow-filled nests of departed*
> *sora and wren . . .*

Her poem "Because You Understand This" (page 37) encourages us to observe carefully:

> *. . . Each ring of the jingle shell, the stalk*
> *of milk thistle, the blowing pine-needle*
> *shadows reaching forward, forward and back,*
> *on the stone walk, all are watching you.*

Bold bands of lavender and periwinkle edge swaths of corn yellow and olive green in Duesberry's *Lupine Field I* (pages 18–19). In "Language and Experience" (page 87) Rogers tells us

> *. . . today I mistook*
> *a blue creekside of lupine for* generosity,
> *the way it held nothing back. O reed*
> *canary grasses and* grace—*someone tell me*
> *the difference again.*

There is no difference. The craving to look to nature for consolation in the face of mortality is as old as humankind and as immediate as each individual's personal present. Our own language and experience tell us this. By transforming nature into art, the consoling structures found in monotypes by Joellyn Duesberry and poems by Pattiann Rogers offer a generous covenant of seasons, one that confirms and celebrates our need.

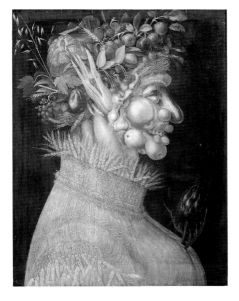

Figure 20 Giuseppe Arcimboldo (Italian, 1527–1593), *Summer,* **1563, oil on panel. Kunsthistorisches Museum, Vienna.**

NOTES

1 Paul Eluard, *Oeuvres Complètes* (Paris: Gallimard, Bibliothèque de la Pléiade, 1968), 982–83. He begins, "In order to collaborate, painters and poets need to see themselves as free." So do viewers as they contemplate works of art, both familiar and unfamiliar.

2 See Rainer Crone et al., *Numerals, 1924–1977*, exh. cat. (New Haven: Yale University Art Gallery, 1978).

3 In the *American Heritage Dictionary of the English Language*, 3d ed. (Boston: Houghton Mifflin, 1996), covenant is defined as: "1. A binding agreement; a compact. See Synonyms at bargain. 2. *Law.* a. A formal sealed agreement or contract. b. A suit to recover damages for violation of such a contract. 3. In the Bible, God's promise to the human race. —covenant *v.* . . . —*tr.* To promise by or as if by a covenant. See Synonyms at promise. —*intr.* To enter into a covenant. [Middle English, from Old French, from present participle of *convenir*, to agree. See CONVENE.]

4 See George Kubler, *The Shape of Time: Remarks on the History of Things* (New Haven: Yale University Press, 1962).

5 Michael Brenson, "In the Arts: Critics' Choices," *New York Times*, 13 November 1983, sec. 2A. Elizabeth Aldrich, review of Duesberry exhibition, *Art/World* 1 (February 1982): 2.

6 Matthew Mason, "Interview with Pattiann Rogers," *Morpo Review* 3, no. 3 (11 April 1996): 1–4 (http://www.novia.net/morpo/v3i3/edit33.html). For the intersection of language, art, and science as applied to nature, see Barbara Stafford, *Voyage into Substance: Art, Science, Nature, and the Illustrated Travel Account, 1760–1840* (Cambridge: M.I.T. Press, 1984).

7 Pattiann Rogers, "Reiteration," *Poetry* 171, no. 3 (January 1998): 200–201.

8 Jeanette Winterson, *Art Objects: Essays on Ecstasy and Effrontery* (New York: Alfred A. Knopf, 1996), xi.

9 Although Durrie was quite prolific, and regularly used seasonal themes in his work, the painting now in the Virginia Museum is one of only ten that were reproduced by Currier and Ives. See *Currier and Ives: A Catalogue Raisonné: A Comprehensive Catalogue of the Lithographs of Nathaniel Currier, James Merritt Ives, and Charles Currier, Including Ephemera Associated with the Firm, 1834–1907* (Detroit: Gale Research Company, 1984). For the ten Durrie paintings reproduced as lithographs, see vol. 2, p. 984. Historians especially valued Durrie's "record of the old-time farm and its life, now vanishing" (Harry T. Peters, *Currier and Ives: Printmakers to the American People* [Garden City, N.Y.: Doubleday, Doran and Company, 1931], 116). Ongoing research in American art and material culture suggests that Americans were uncomfortable with the speed of change much earlier than the post–Civil War "gilded age." Thus Durrie would have found a ready-made audience for his paintings by the time his career was fully launched in the 1840s.

10 A central component of Marian worship during the Middle Ages, books of hours follow the Catholic Church's liturgical year and derive their generic name from a series of prayers, "Hours of the Virgin." For a discussion of these sophisticated and complex books, see Roger S. Wieck, *Painted Prayers: The Book of Hours in Medieval and Renaissance Art* (New York: George Braziller, 1997), which accompanied an exhibition at the Pierpont Morgan Library, New York, titled *Medieval Bestseller: The Book of Hours*.

11 See Fritz Grossmann, *Bruegel: The Paintings* (London: Phaidon, 1955), 197–99.

12 Three pictures are in Vienna, one is in Prague, one is in New York, and one is apparently lost. Curators at the Kunsthistorisches Museum in Vienna have ordered the extant pictures as follows: *The Gloomy Day* (Kunsthistorisches Museum, Vienna); *Hay Making* (National Gallery, Prague); *The Corn Harvest* (Metropolitan Museum of Art, New York); *The Return of the Herd* (Kunsthistorisches Museum, Vienna); and *Hunters in the Snow* (Kunsthistorisches Museum, Vienna). It was once believed that there were twelve pictures in the series, but curators in Vienna no longer accept this theory.

13 For her master's thesis at the Institute of Fine Arts, New York University, Duesberry studied Bruegel's landscapes. In a recent essay on Charles Burchfield's engagement with the four seasons, Michael Kammen notes (in "Charles Burchfield and the Procession of the Seasons," in Nannette V. Maciejunes and Michael D. Hall, *The Paintings of Charles Burchfield: North by Midwest*, exh. cat. [New York: Harry N. Abrams for the Columbus Museum of Art, 1997], 41):

Contemporary artists who paint the seasons, such as James McGarrell, Jasper Johns, David Campbell, Brice Marden, Robert Jessup, Anne Abrons, and David Sharpe, do not comprise a community, and they are only slightly aware of or interested in one another's depictions of these subjects. Moreover, if you ask them what previous painters of the seasons they know about or have an interest in, they are not likely to mention any American forebears. Instead they are likely to mention Pieter Bruegel. . . . There seems to be a curiously deceptive memory that sometime, somewhere (the Rijksmuseum in Amsterdam?), "I saw and loved Brueghel's *Four Seasons*."

I would suggest that one reason these contemporary artists are not a "community" is that the seasons belong to everybody.

14 Simon Schama, *Landscape and Memory* (New York: Alfred A. Knopf, 1995), 16.

15 Engaging gardening tomes that follow this very appropriate structure are two books from 1894: Mrs. William Starr Dana's *According to Season: A Celebration of Nature* (reprint, Boston: Houghton Mifflin Company, 1990), and poet Celia Thaxter's *An Island Garden* (reprint, Boston: Houghton Mifflin Company, 1988). Each includes images as well as text, with illustrations by Elsie Louise Shaw in the first case, and Childe Hassam in the second. A most evocative cookbook built around the seasons is Elizabeth Romer, *The Tuscan Year: Life and Food in an Italian Valley* (New York: Atheneum, 1985). Socialite and art collector Mabel Dodge Luhan's recollection of the Southwest, *Winter in Taos* (New York: Harcourt, Brace and Company, 1935), is filled with memorable imagery of the Taos Valley at a time of year when few tourists were there.

16 Widespread use of Durrie's *Winter in the Country* is typified by a box of especially repellent greeting cards, with Durrie's painting badly reproduced on shimmering acetate, which I found at the time the Virginia Museum was in the process of acquiring the painting.

17 For Schubert, a "cycle" did not carry the comparatively strict formal implications it was to bear later in the nineteenth century; Schubert did not aim at a thematic development through these large song collections, but sought poetic, dramatic, and psychological unity. See Geoffrey Hindley, ed., *Larousse Encyclopedia of Music* (London: Hamlyn, 1971), 275.

18 Program notes to Franz Schubert, *Winterreise D 911*, Deutsche Grammophon, compact disk, CD 447 421–2.

19 Letter, Rogers to Curry, 18 November 1997.

20 The plan of the room was sent to London, where the paper was designed exactly to fit. The wallpaper arrived in New York in October 1768. According to Marshall B. Davidson and Elizabeth Stillinger (*The American Wing at the Metropolitan Museum of Art* [New York: Alfred A. Knopf, 1985], 52–53):
Scenes of antique Italian ruins and such perennial favorites as the four seasons and the four elements were painted in grisaille (shades of gray) on a yellow ground and framed by lively rococo cartouches. This series of enframed scenes created an atmosphere not too different from that of the picture-hung halls of English manor houses that Stephen Van Rensselaer was emulating.

21 A visitor to the recent Charles Burchfield exhibition at the National Museum of American Art in Washington stood in the section devoted to seasonal imagery in the artist's work and complained, "Winter doesn't look like that in California." One might want to recall not only that the seasons vary for different people in different locales, but also that commercialism ensures a ready stream of standard seasonal imagery geared to the calendar year, from the metallic sparkle that welcomes in the January white sales to the red and green tinsel of the "holidays."

22 Mark Roskill, *The Languages of Landscape* (University Park: Penn State Press, 1997), 4.

23 Artists make monotypes by drawing with printer's ink, oil paint, or some other medium on a smooth surface such as glass, Plexiglas, or metal plates. The image is transferred from the hard surface to a soft one by running the plate through a printing press—or by applying some other means of pressure, from the palm of a hand or the back of a spoon to a brayer (a special kind of hard rubber roller). The inks are transferred to paper (usually) or fabric. The artist has to work quickly before the ink dries. Most of the ink is transferred during the initial printing so that only one strong impression (hence, "monotype") can be made. It is sometimes possible to pull a second faint or "ghost" image as well. For a recent study of the history of monotypes, see Joann Moser, *Singular Impressions: The Monotype in America*, exh. cat. (Washington, D.C.: National Museum of American Art and Smithsonian Institution Press, 1997).

24 Mary Voelz Chandler, "Exhibitions Addressing Art as Heart and as Political Passion," *Rocky Mountain News* (Denver), 27 January 1995. A recent review of new landscapes by Color Field artist Jules Olitski brought this comment: "What's surprising about them is that they are landscapes— unabashed, recognizable, and so gorgeous that they risk critical scoldings" (Dodie Kazanjian, "Olitski's Surprises," *New Yorker* 72, no. 21 [29 July 1996]: 72). That such negative or timid critical responses to beauty seem almost predictable at present suggests to me that it is time to encourage other reactions.

25 Leslie Ullman, review of Pattiann Rogers, *Firekeeper: New and Selected Poems*, in *Poetry* 169, no. 2 (December 1996): 160–63.

26 Oscar Wilde, *The Picture of Dorian Gray and Other Writings by Oscar Wilde*, ed. Richard Ellman (New York: Bantam Books, 1982), 21. Beauty remains dangerous today, as a large body of critical writing attests. See, for example, Ruth Lorand, "Beauty and Its Opposites," *Journal of Aesthetics and Art Criticism* 52, no. 4 (Fall 1994): 399–406. For potential dilemmas that aesthetics can cause in museums, see Ivan Karp and Steven D. Lavine, eds., *Exhibiting Cultures: The Poetics and Politics of Museum Display* (Washington, D.C.: Smithsonian Institution Press, 1991).

27 Pattiann Rogers, "The Possible Salvation of Continuous Motion," in *Firekeeper, New and Selected Poems* (Minneapolis: Milkweed Editions, 1994), 65–66.

28 Schama, *Landscape and Memory*, 14.

29 Pattiann Rogers, "Till My Teeth Rattle," in *Firekeeper: New and Selected Poems*, 209–10.

30 For discussion, see Elwood C. Parry III, "Still a Youth in Imagination," in *The Art of Thomas Cole: Ambition and Imagination* (Newark: University of Delaware Press, 1988), 226–68. For more recent commentary, see William H. Truettner and Alan Wallach, eds., *Thomas Cole: Landscape into History*, exh. cat. (New Haven: Yale University Press for National Museum of American Art, 1994).

31 Thomas Seir Cummings, *New-York Mirror*, 2 January 1841; cited in Parry, "Still a Youth in Imagination," 226.

32 Michael Wentworth, "The Earthly Paradise," in *James Tissot* (Oxford: Clarendon Press, 1984), 127. He notes (p. 128):
Remarks in *Punch* about the Grove End Road pictures exhibited at the Grosvenor Gallery, referring to their settings as "Fair Rosamund's Bower-villa, N.W.," are surely too accurately pointed to be general references, and they echo the more gener- alized moral indignation of periodicals like the *Spectator*. Far from keeping her a hidden beauty, Tissot flaunted Mrs. Newton and the liaison in his pictures, and his continued reference to his domestic arrangements is undoubtedly the source of the moral indignation directed against his pictures at the end of the decade. That a pretty woman of equivocal position and with children of mysterious antecedents was able to enjoy herself in such obvious tranquillity was bad enough, but that the Grosvenor Gallery exhibitions were made the stage for the public display of her happiness was an affront too great to be borne with equanimity.

33 Ibid., 129. He adds (p. 134):
In most of the pictures in which Mrs. Newton is seen in a public setting, Tissot portrays her as she would appear to an outsider. Even when he depicts himself with her, admiring or protective, the impression she makes is the one he might proudly have imagined—that of a beautiful stranger glimpsed and admired, but soon lost, in the flow of urban life, whose chance regard, sometimes almost hostile, established a fleeting contact which at once paradoxically enhances and destroys the anonymous quality of city life.

34 Based on the eighteenth-century marbles now in the Jardin des Tuileries, these monumental works were probably commissioned during the mid–nineteenth century when further copies were made for the Parc de Saint-Cloud. For reproductions of *Pomona*'s companions, see *The Arts of France*, auction cat., Christie's, New York, 21 October 1997. The original source for the figure of Pomona is a marble term carved by François Barois, ca. 1686–96, after designs by François Girardon, originally intended for and placed in the garden at Versailles.

35 As promulgated by Sir Joshua Reynolds in his sixth discourse (10 December 1774) to the Royal Academy in London, "genius begins where rules end," while invention is "acquired by being conversant with the inventions of others," and there is "something to be gathered from every school"; *Sir Joshua Reynolds' Discourses*, ed. Helen Zimmern (London: Walter Scott, 1887), 74–97.

36 M. S. Mason, "Where Canvas Meets Spirit of Place," *Christian Science Monitor*, 9 November 1992, 16 (review of the exhibition *Joellyn Duesberry, Landscapes, 1972–1992* at the Denver Art Museum).

37 See Henri Focillon, *Vie des formes*, 3d ed. (Paris: Presses Universitaires de France, 1947).

38 David Shapiro, "Poets and Painters: Lines of Color: Theory and Some Important Precursors," in *Poets and Painters*, exh. cat. (Denver: Denver Art Museum, 1979), 8. Shapiro writes (p. 8): "The poet must take a stance for or against grammar, but cannot escape its rule systems. And so the artist is locked in a constant and shifting dialectical *agon* with the forces of geometry." See also Roman Jakobson, "Poetry of Grammar and the Grammar of Poetry," *Lingua* 21 (1968): 597–609, as well as Roman Jakobson and Linda R. Waugh, *The Sound Shape of Language* (Bloomington: Indiana University Press, 1979).

39 Mason, "Interview with Pattiann Rogers," 3.

40 Duesberry quoted in Marilynne S. Mason, "Metaphor for Urgency," *Colorado Expression* (Denver), spring 1995.

41 Shapiro, "Poets and Painters," 7. For a study of screens in Western art, see Michael Komanecky and Virginia Fabbri Butera, *The Folding Image: Screens by Western Artists of the Nineteenth and Twentieth Centuries*, exh. cat. (New Haven: Yale University Art Gallery, 1984). Alan Filreis has commented on the impact of art from the East on Western poets and painters, underscoring that Western scholars sometimes generalize on both the "poetic feeling" of Oriental painting and the pictorial characteristics of Chinese and Japanese poetry. He adds:

In China poets were often painters; and critics, particularly in the eleventh and twelfth centuries, stated the parallelism of poetry and painting in language close to that of Simonides and Horace. According to Chou Sun, "Painting and writing are one and the same art." Writing implied calligraphy, which linked painting with poetry. Thus, a poet might "paint poetry," and a painter wrote "soundless poems."

Alan Filreis, "Beyond the Rhetorician's Touch: Stevens's Painterly Abstractions," in *American Literary History* (http://www.english.upenn.edu/~afilreis/88/utpict.html). This essay treats Wallace Stevens, the Cold War, American attitudes toward Europe, and Abstract Expressionism.

42 Edo's highly varied topography allowed its citizens to celebrate the changing seasons in a variety of festivals and ceremonies. Some of these celebrations are recorded in books such as the *Edo Kanoko*, published in 1687. The title, a Japanese play on words, derives from the spots on a faun, but actually addresses "spots" around Edo where good views were to be found. The six-volume book includes views of regularly used sites where celebrations focused on specific seasons, transient weather effects, or times of day: "the evening rain at the Sumida River," "the full moon in autumn at Shinobu-no-oka," "the evening bell tolling at Zojjoti temple," "boats returning at Teppozu," "fair weather at Asakusa," "sundown at Atago," "snow at Nippon," and "flying geese at Meguro." The celebrations were ritualized, which may help explain their survival in modern Japanese culture. Spring cherry blossom viewing, for example, originated from agricultural festivities designed to ensure a bountiful harvest in the coming year. See Nishiyama Matsunosuke et al., *Guide to Edo-Tokyo Museum* (Tokyo: Foundation Edo-Tokyo Historical Society, 1995), 70–71. I am grateful to Ann Yonemura, associate curator of Japanese Art at the Freer and Sackler Galleries, Smithsonian Institution, for her help in explaining the *Edo Kanoko.*

Glimpses of the moon in Rogers's poetry—"...the unseen / blue-white glow of the black new / moon..." ("My Brides," page 65)—restate the constant waxing and waning of the moon and resonate for me in the moon-viewing parties that still take place in Japan in the autumn.

43 Reproduced in Taizo Kuroda, Melinda Takeuchi, and Yazo Yamane, *Worlds Seen and Imagined: Japanese Screens from the Idemitsu Museum of Arts*, exh. cat. (New York: Abbeville Press for Asia Society Galleries, 1995), cat. no. 2.

44 Reproduced in ibid., cat. no. 30.

45 This poem from the *Tales of Ise* is cited in ibid., 150. The Heian period refers to the years 794–1185, when the city now called Kyoto served as Japan's imperial capital. The city remained the emperor's residence almost continuously until 1868 and is still considered "the old capital." See *Guide to Edo-Tokyo Museum*, 160. Another related set of folding screens painted by Ogata Korin simply shows dozens of irises (Nezu Museum, Tokyo). A copy of the Korin screen with the wooden bridge was painted in the eighteenth century by Sakai Hoitsu and is now in the Idemitsu Museum.

46 Pattiann Rogers, "The Compassion of the Iris," in *The Tattooed Lady in the Garden* (Middletown, Conn.: Wesleyan University Press, 1986), 83.

47 Even if I had never sat in her garden, I would enjoy the splash of colors in Duesberry's images of that spot, just as viewers unfamiliar with ancient Japanese poetry can still enjoy Korin's screens for their elegant formality and glimmering surfaces of rich blue and green against gold. But contemporary art, like any other, is much richer and more engaging when seen in some kind of context.

48 Shapiro, "Poets and Painters," 9.

49 Charles Burchfield, journal entry, 29 March 1943; cited in Kammen, "Charles Burchfield and the Procession of the Seasons," 38.

50 Thomas Seedorf, program notes to Antonio Vivaldi, *The Four Seasons*, recorded by the Harp Consort for Deutsche Harmonia Mundi, compact disk, 05472–77384–2. Essentially, program music attempts to conjure up nonmusical ideas, to capture a physical event or story or literary concept through sound. See Luciano Alberti, *Music of the Western World*, trans. Richard Pierce (New York: Crown, 1974), 125–26.

51 Vivaldi was overlooked until musicologists engaged in the revival of Johann Sebastian Bach discovered that Bach had transcribed much of Vivaldi's work. See Donald Jay Grout and Claude V. Palsica, *A History of Western Music*, 4th ed. (New York: W. W. Norton, 1988), 489.

52 Hindley, *Larousse Encyclopedia of Music*, 24, 206.

53 The poems are included in program notes to the Harp Consort's recording of *The Four Seasons* (cited above). They are also read in Italian at the end of the disk.

54 *For All Seasons*, vol. 12 of *Golden Baroque*, Phillips Digital Classics, compact disk, 454 414–2 DDD.

55 Four Seasons vase by Waterford, CyberShop Home (America Online), 1997.

56 Shapiro ("Poets and Painters," 27) provides a brief bibliography of studies on this topic. For the relations of the arts in the Middle Ages and the Renaissance, see Rensselaer W. Lee, *Ut Pictura Poesis: The Humanistic Theory of Painting* (New York: W. W. Norton, 1967), and Meyer Schapiro, *Words and Pictures: On the Literal and the Symbolic in the Illustration of a Text* (Hawthorne, N.Y.: Mouton Publications, 1973). These are just two of the studies cited in Shapiro's thoughtful piece.

57 Filreis, "Beyond the Rhetorician's Touch."

58 Ibid.

59 Clayton Eshleman and Annette Smith take this approach in their discussion of "involun-

tary but significant similarity" between the poems of Aime Cesaire and drawings by Pablo Picasso, in *Lost Body (Corps Perdu)* (New York: George Braziller, 1986), xix ff.

60 James McNeill Whistler, "The Ten o'Clock Lecture" (1885), reprinted in *The Gentle Art of Making Enemies* (New York: G. P. Putnam's Sons, 1916), 143.

61 See Douglas Chambers, "Smoothing or Brushing the Robe of Nature: William Shenstone and the Leasowes," in *The Planters of the English Landscape Garden: Botany, Trees, and the "Georgics"* (New Haven and London: Yale University Press, 1993), 177–84.

62 Roy Strong, "Garden of the Mind," *House and Garden* 52, no. 2 (February 1997): 111–12.

63 Ibid., 112.

64 Jasper Francis Cropsey (1847), cited in David Park Curry, Elizabeth L. O'Leary, and Susan Jensen Rawles, *American Dreams: Paintings and Decorative Arts from the Warner Collection*, exh. cat. (Richmond: Virginia Museum of Fine Arts, 1997), 22.

65 Whistler, "The Ten o'Clock Lecture," 143.

66 Roskill, *The Languages of Landscape*, 4.

67 Of course not only the American landscape but also its original occupants were subject to editing if Manifest Destiny was to function. Simon Schama notes that "both the mining companies who had first penetrated this area of the Sierra Nevada and the expelled Ahwahneechee Indians were carefully and forcibly edited out of the idyll" we now think of as Yosemite Park; Schama, *Landscape and Memory*, 7–8.

68 Ibid., 6–7.

69 Pattiann Rogers, "Betrayal: The Reflection of the Cattail," in *The Tattooed Lady in the Garden*, 26–27.

70 Schama, *Landscape and Memory*, 7–8. The Ahwahneechee Indians, original inhabitants of the area, regularly burned off the underbrush, creating the "natural" meadows Muir found so moving. Schama brings forth René Magritte's 1938 argument that "culture, convention, and cognition" make the design that individuals recognize as beauty. He adds, "It is exactly this kind of presumption that many contemporary landscapists find so offensive [but] the old culture-creatures emerge from their lair, trailing the memories of generations behind them" (p. 12). These old ways resurface yet again in Duesberry's image of a burnt meadow near her home (*Burnt Meadow, South Platte River V,* page 24).

For the Edenic associations of national parks, see John F. Sears, *Sacred Places: American Tourist Attractions in the Nineteenth Century* (Oxford: Oxford University Press, 1989). For economically driven tourism in New England, see Dona Brown, *Inventing New England: Regional Tourism in the Nineteenth Century* (Washington, D.C., and London: Smithsonian Institution Press, 1995).

71 Quoted in Maynard Solomon, *Mozart: A Life* (New York: HarperPerennial, 1995), 197.

72 Ibid.

73 E. Alfred Jones, *Illustrated Catalogue of the Collection of Old Plate of J. Pierpont Morgan, Esquire* (London: Bemrose and Sons, 1908), 104, pl. XCIV.

74 I am grateful to Christopher McConnell at the Graduate Theological Union, Berkeley, for help with this translation.

75 Pattiann Rogers, "What the Sea Means to a Rock Barnacle in a Tidal Pool," in *Geocentric* (Salt Lake City: Gibbs-Smith, 1993), 16.

76 John Dewey, *Art as Experience* (1934), 147–48; quoted in Solomon, *Mozart*, 194.

77 Pattiann Rogers, "Easter Frogs," *Seattle Review* 19, no. 1 (1997): 43–44.

78 Roland Barthes, "Arcimboldo: Monstres et merveilles," *L'Oeil*, no. 485 (May 1997): 36–46. For a recent study of the lasting significance of the capriccio, see *Das Capriccio als Kunstprinzip: Zur Vorgeschichte der Moderne von Arcimboldo und Callot bis Tiepolo und Goya, Malerei—Zeichnung—Graphik*, exh. cat. (Milan: Skira for the Kunsthistorisches Museum, Vienna, 1997).

79 Ullman, review, 161.

ACKNOWLEDGMENTS
AND DEDICATIONS

Over a decade ago Richard Diebenkorn urged me with his usual empathy and prescience to tackle the medium of monotype, in order to "uncover the bones" of my painting. I and countless others mourn the impossibility of thanking him personally for the fruit of his painterly wisdom. Urging me to persevere in this new medium were sustaining friendships: hope and critical support arrived regularly from Bill O'Reilly, Marina and Bill Beadleston, Lee Bailey, Lewis Sharp, Deborah Jordy, Jan and Fred Mayer; loyalty compounded with extraordinary generosity came from Charles Hamlin, Nancy Benson, Joan and David Smith, and Gaylord Neely. As the project grew I enjoyed constant encouragement from John Walsh, Roger Mandle, and the photographer and writer Robert Adams, who introduced us to the landscape poetry of Pattiann Rogers. The art historian Dr. David Park Curry long ago proposed the project and has tirelessly maintained its vitality with inspiration, brilliant insights, and believable prose. His wife Rebecca Morter aided us all with cheerful efficiency, as did his research assistant Elizabeth O'Leary. Dr. Curry's colleague at the Virginia Museum, Eileen Mott, is generously shepherding the monotypes and poems to national museum venues in her capacity as Curator of State-wide Exhibition Programs. My assistants Shannon Corrigan and Wendy Heisterkamp have wrought miracles of organization in preparing this second phase of the endeavor. Paul Anbinder and his designer, Betty Binns, have joyfully turned all this labor into a beautiful, adventuresome book. Integral to this painter's history and conscience was the sculptor, the late Gonzalo Fonseca, who did not see the completed arc of thought he fostered. With ultimate gratitude to Ira, my husband, refuge, anchor, and celebrant, I dedicate the images in *A Covenant of Seasons*.

JOELLYN DUESBERRY

I wish to dedicate the poems in this book to my brother, William E. Tall, in gratitude for the energy of his art and for the early and lasting example of his talent and imagination.

PATTIANN ROGERS